Sentinels in the Stream

LIGHTHOUSES OF THE ST. LAWRENCE RIVER

Text and Photography

GEORGE FISCHER & CLAUDE BOUCHARD

The BOSTON
MILLS PRESS

I dedicate this book to my mother, Elizabeth Fischer, who, despite numerous obstacles, had the courage, strength and determination to see to it that my brother Karl, sister Kathy and I would live in a free country where we could pursue our hopes and dreams for ourselves and for our children. Our family sailed across the Atlantic aboard the *Ascania*, departing from Le Havre, France, on July 11, 1957, when I was three years old. We entered the mouth of the mighty St. Lawrence on July 19 and passed many of the lighthouses depicted in this book as they guided us to the safe harbor of Québec City. For my mother, Canada was the guiding light in the storm, the beacon of hope and the safety and security she searched for in a world she had seen turned upside-down by revolution and war. These pillars of strength and fortitude are dedicated to her perseverance. GF

To my wife, Linda, and my daughters, Judith, Catherine, Roseline and Agnès, the lights in my life. CB

CANADIAN CATALOGUING IN PUBLICATION DATA

Fischer, George, 1954–
Sentinels in the stream: lighthouses of the St. Lawrence River

ISBN 1-55046-353-5

1. Lighthouses — Saint Lawrence River — Pictorial works. 2. Lighthouses —
Saint Lawrence River — History. I. Bouchard, Claude, 1950 Dec. 29– . II. Title

VK1027.S24F57 2001 387.1'55'09714 2001-930044-1

05 04 03 02 01 1 2 3 4 5

Published in 2001 by
BOSTON MILLS PRESS
132 Main Street
Erin, Ontario
Canada N0B 1T0
Tel 519-833-2407
Fax 519-833-2195
e-mail books@bostonmillspress.com
www.bostonmillspress.com

An affiliate of
STODDART PUBLISHING CO. LIMITED
895 Don Mills Road
#400 2 Park Centre
Toronto, Ontario
Canada M3C 1W3
Tel 416-445-3333
Fax 416-445-5967
e-mail gdsinc@genpub.com

Distributed in Canada by
General Distribution Services Limited
325 Humber College Boulevard
Toronto, Canada M9W 7C3
Orders 1-800-387-0141 Ontario & Quebec
Orders 1-800-387-0172 NW Ontario & other provinces
e-mail cservice@genpub.com

Distributed in the United States by
General Distribution Services Inc.
PMB 128, 4500 Witmer Industrial Estates
Niagara Falls, New York 14305-1386
Toll-free 1-800-805-1083
Toll-free fax 1-800-481-6207
e-mail gdsinc@genpub.com
www.genpub.com

THE CANADA COUNCIL | LE CONSEIL DES ARTS
FOR THE ARTS | DU CANADA
SINCE 1957 | DEPUIS 1957

We acknowledge for their financial support of our publishing
program the Canada Council, the Ontario Arts Council, and
the Government of Canada through the Book Publishing
Industry Development Program (BPIDP).

Design by Gillian Stead
English Translation of Claude Bouchard's text by José Demers Beaudet

Printed in Canada

Contents

Forewords

Lighthouses are a direct link to our past. They have molded our history and our economy. The Great Lakes and the St. Lawrence Seaway bore witness to the invaluable contribution of our lighthouses, which beckoned millions of newcomers to a safe landing and warned mariners of potential hazards to their vessels.

The Great Lakes make up the world's largest inland waterway. They flow into the St. Lawrence River, just past the picturesque town of Napanee and our beautiful Thousand Islands, a vital Eastern Ontario tourism area where heritage sites and lighthouses abound. The breathtaking beauty of this region contrasts with some of the most challenging waters in the world to navigate. Lighthouses are the beacons of traditions past, and in Loyalist times, they were the only safeguard for thousands of vessels carrying precious cargo.

While lighthouses and their brave keepers have been replaced by modern navigation equipment, the remaining structures stand proud as reminders of an era when maritime commerce was as prominent as electronic commerce is today.

I invite you to relive the historical magic of the great lights in this superb collection of images and writings, and to find out why there truly is "More to Discover" in Ontario.

<div align="right">Cam Jackson, Ontario Minister of Tourism</div>

For more than 150 years, the lighthouses of the St. Lawrence have guided navigators. Shipwrecks were once common, but today have been almost eliminated.

Until the 1960s, lighthouse keepers and their families were solely responsible for the functions of the lighthouses that are at the heart of Québec's maritime history. In *Sentinels in the Stream: Lighthouses of the St. Lawrence River,* authors Claude Bouchard and George Fischer have chosen to be the keepers of this history.

Today, the St. Lawrence lighthouses are also part of our tourism heritage. Eco-tourism enthusiasts are pleased to visit those places where the history of the sites and the ecosystem that surrounds them are respected. The lighthouses have become privileged sites for the observation of the surrounding nature.

This magnificent work shows, in texts and in pictures, a collection of some 43 lighthouses on this great river, from Kingston to Îles-de-la-Madeleine. Here is an incomparable tourism circuit that will permit foreign and Québec visitors alike to discover an extraordinary maritime history along one of the most majestic bodies of water on the planet.

<div align="right">Maxime Arseneau, Québec Minister of Tourism</div>

Preface

The first navigators of the St. Lawrence River were the Native Americans. The river was their primary trade and transportation route. They traveled by birchbark and dugout canoe, without the aid of modern contrivances such as charts, buoys and lighthouses. Yet their local knowledge of the river was so vast that no European explorer would venture very far upriver without their guides, or, as we would call them today, pilots. In fact, this tradition would continue well into the twentieth century. Passenger ships that "shot the rapids" usually did so with a local Native at the helm.

History tells us that the first European to sail the St. Lawrence was Jacques Cartier. He was commissioned by King Francis I to "discover certain lands where it is said there is a large amount of gold and other riches to be found." In 1534 he explored the Gulf of St. Lawrence and the following year traveled upriver to the foot of the rapids to what is now present-day Montréal. In his journal, Cartier described the St. Lawrence as "incomparably the largest river anyone has ever seen — as far as is known!" The identity of the first European to explore the Upper St. Lawrence and Thousand Islands has been lost to history. However, it was likely a "voyageur" in search of pelts or other trade goods. In 1654 Father Simon La Moine, a Jesuit missionary, became the first to make a record of his trip from Montréal to Lake Ontario.

Lighthouses pre-date modern North American history by almost two millennia. The first lighthouses in the world were fire towers, masonry towers built on important headlands on the shores of Europe and Africa, on which bonfires were burnt. The most famous early lighthouse is Pharos, a huge and elaborate structure built on an island outside the harbor of Alexandria in 285 B.C. It was considered one of the seven wonders of the ancient world.

The French at Louisbourg, Nova Scotia, built the first Canadian lighthouse. Construction began in 1731 and the lantern was first lit in 1734. Unfortunately, Canada's first lighthouse was to stand for a mere 24 years. In June of 1758, during the second British siege of Louisbourg, the tower was damaged beyond repair. The oldest original operational lighthouse in North America is located on Sambro Island, just outside the entrance to Halifax harbor. It was built in 1758. The first lighthouse on the St. Lawrence was Île-Verte lighthouse, built between 1806 and 1809. It is located at the mouth of the Saguenay River and is still in operation.

The first North American lighthouses were illuminated using whale oil, principally from the sperm whale. In 1846, just before whales were hunted to near extinction, a Canadian, Dr. Abraham Gesner, invented a process for distilling kerosene from coal. It burned cleaner, brighter, and was less expensive than whale oil, and by the 1860s most lighthouses on the Upper St. Lawrence had converted to the "new" coal oil. Some historians believe that Dr. Gesner saved more whales than Greenpeace ever will. Coal oil was used in some locations up until the 1950s. In 1902, a gas, acetylene, was first tried at the Father Point, Québec, lighthouse. The results were so promising that in the following year all kerosene lights on the Upper St. Lawrence were converted to acetylene. Acetylene had the advantage of being much brighter than coal oil, and it could be left unattended for longer periods of time. The gas was released through a nozzle, or jet, so there were no wicks to be trimmed — one of the reasons coal oil lights had to be tended to so frequently. Reed Point, New Brunswick, was the first Canadian lighthouse to display an electric light, in 1895. Electrification continued throughout the twentieth century as power distribution systems reached the outlying areas and technological improvements were made to batteries and generating systems. The late 1970s saw the installation of solar power at many small lights. Improvements to this technology continued, and by the 1990s many isolated major light stations were solarized.

The early days of lighthouse keeping were very difficult. The lightkeepers had to constantly trim the wicks and clean and polish the soot from the chimneys and lenses. At the larger lights, huge Fresnel lenses weighing up to a ton "floated" in mercury baths. These lenses rotated by a mechanism utilizing weights that slowly dropped through the center of the tower, similar to the way a wall cuckoo clock operates. The lightkeeper had to hand-crank these weights back up to the top of the tower several times a day, more often during cold weather. Early foghorns were also hand-cranked. In addition to all these duties, the lightkeeper had to maintain the tower, buildings and dwellings. The first lightkeepers had to hire and pay out of pocket for their assistants, perhaps one of the reasons that assistants were often family members. In some cases, a light would be tended by several generations of the same family. With the advent of technology and electrification, the duties of the lightkeeper diminished. Canada began its "automation" program in the mid-1970s, installing reliable new diesel generators, replacing many of the old Fresnel lenses with flashing lights, and replacing the old compressed-air foghorns with new electronic versions. The equipment required little maintenance. Over the next decade, retiring lightkeepers were not replaced, smaller stations were de-staffed, personnel assigned elsewhere, and finally the last lighthouse keepers of the St. Lawrence were removed from Prince Shoal, in 1988.

The technology available to today's mariner has changed even more dramatically than the changes to lighthouse equipment. The development of electronic shipboard navigation equipment has eroded the importance and reliance that mariners once placed on these lighthouses. Today's commercial vessels are likely to be equipped with radar, differential global positioning systems and electronic charts. A vessel's position is calculated from satellite signals, corrected from a

differential shore station and plotted on an electronic chart. This is then displayed on a video monitor. Information from the ship's radar, such as the location of other vessels, can even be overlaid on the display. As with most new technology, the cost of these systems is continually dropping, and it is just now becoming available to fishermen and recreational boaters.

So, what is to become of our lighthouses, the "sentinels of the stream"? In many cases, the Coast Guard will continue to operate them as aids to navigation. Despite all our modern conveniences, while navigating in confined channels near dangerous obstructions the prudent mariner will always want to look out the pilothouse window and be assured by a flashing light — hopefully, where he expects it to be! Also, many smaller vessels are not yet, and may never be, equipped with state-of-the-art electronic navigation equipment. When providing aids to navigation service, the Coast Guard is mindful of designing it to meet the needs of the least capable user. However, some lighthouses are being declared surplus, such as those distant from modern shipping lanes, or in small harbor villages that no longer receive the traffic they once did. The Canadian Coast Guard has embarked on a project called the "Light Station Alternative Use Program." It allows communities, groups and individuals to submit ideas and suggestions for the alternative re-use of light stations. These uses may take the form of parks, tourist information booths, restaurants, and even bed-and-breakfasts. Some of these lighthouses may no longer be the important aid to navigation they once were, but thanks to Canadians interested in preserving their marine cultural heritage, their future is assured.

Ted Cater
Marine Aids Officer
Canadian Coast Guard
Prescott, Ontario

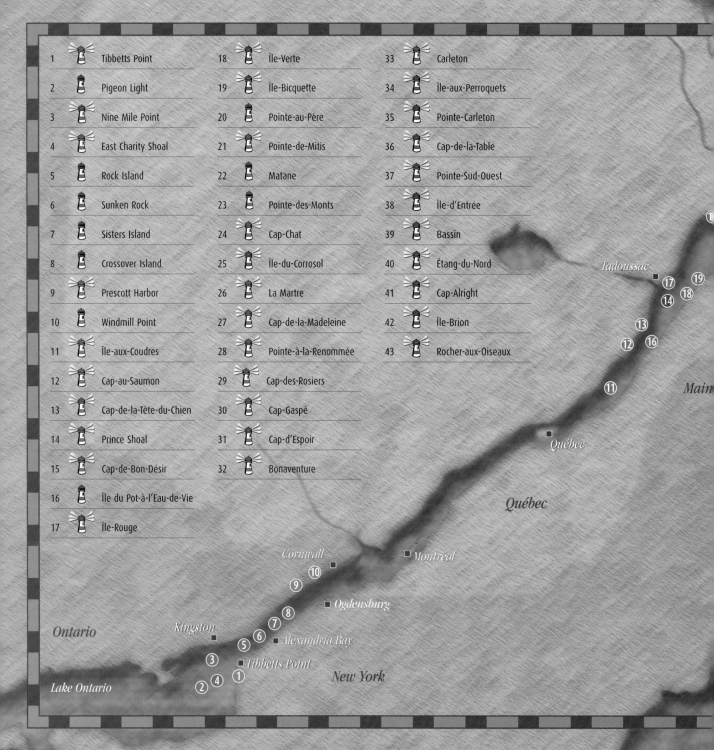

1 Tibbetts Point
2 Pigeon Light
3 Nine Mile Point
4 East Charity Shoal
5 Rock Island
6 Sunken Rock
7 Sisters Island
8 Crossover Island
9 Prescott Harbor
10 Windmill Point
11 Île-aux-Coudres
12 Cap-au-Saumon
13 Cap-de-la-Tête-du-Chien
14 Prince Shoal
15 Cap-de-Bon-Désir
16 Île du Pot-à-l'Eau-de-Vie
17 Île-Rouge

18 Île-Verte
19 Île-Bicquette
20 Pointe-au-Père
21 Pointe-de-Mitis
22 Matane
23 Pointe-des-Monts
24 Cap-Chat
25 Île-du-Corrosol
26 La Martre
27 Cap-de-la-Madeleine
28 Pointe-à-la-Renommée
29 Cap-des-Rosiers
30 Cap-Gaspé
31 Cap-d'Espoir
32 Bonaventure

33 Carleton
34 Île-aux-Perroquets
35 Pointe-Carleton
36 Cap-de-la-Table
37 Pointe-Sud-Ouest
38 Île-d'Entrée
39 Bassin
40 Étang-du-Nord
41 Cap-Alright
42 Île-Brion
43 Rocher-aux-Oiseaux

Tadoussac

Québec

Québec

Maine

Cornwall
Montréal
Ogdensburg
Ontario
Kingston
Alexandria Bay
Tibbetts Point
New York
Lake Ontario

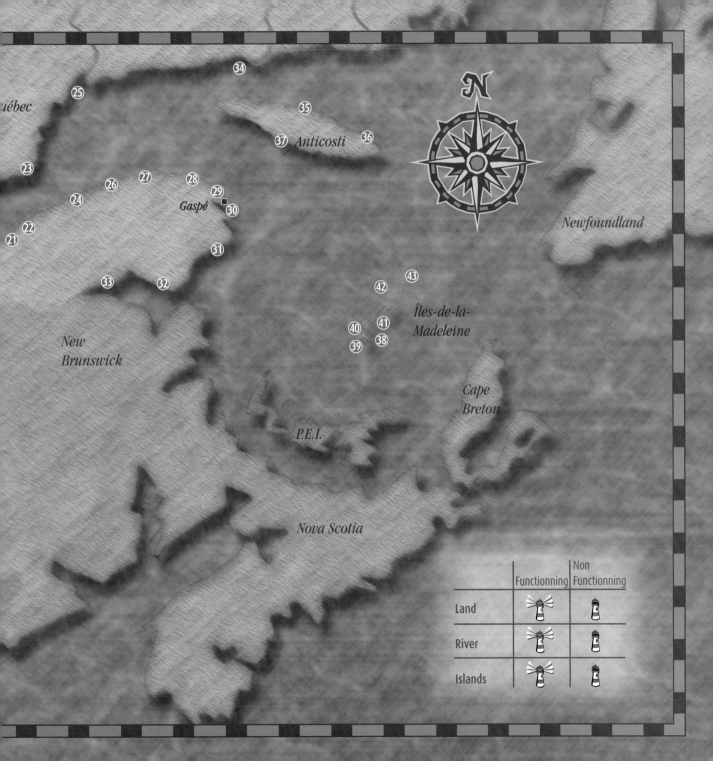

Québec

Anticosti

Newfoundland

Gaspé

New
Brunswick

Îles-de-la-
Madeleine

Cape
Breton

P.E.I.

Nova Scotia

| | Functionning | Non
Functionning |
| --- | --- | --- |
| Land | | |
| River | | |
| Islands | | |

Tibbetts Point

This lighthouse marks the entrance to the St. Lawrence River from Lake Ontario and was built in 1827 to commemorate the importance of the light to shipping and navigation on the river. It's a 20-minute ferry ride from Kingston to Wolfe Island, followed by a 15-minute drive to the Horne ferry, the only international automobile-and-passenger ferry from Canada to the United States.

After a short crossing you arrive in Cape Vincent. The drive along the river's edge from Cape Vincent to Tibbetts Point is dotted with magnificent Victorian summer homes facing Lake Ontario, so drive slowly and enjoy the view.

The original Tibbetts Point lighthouse was replaced in 1854 with the present tower, which rises to a height of 69 feet (21 m) and has a fourth-order Fresnel lens. It remains in operation today and is the oldest operational Fresnel on the St. Lawrence. In 1895 Tibbetts lightkeeper David Montonna supervised the installation of a steam diaphone foghorn that in later years was converted to electric and then to diesel. Though still functional, the foghorn has been replaced by a much quieter radio beacon, apparently because Cape Vincent and Wolfe Island residents were routinely robbed of a peaceful night's sleep by the regular blasts that shook their homes.

Edward Sweet, the last lightkeeper at Tibbetts, retired in 1938, after which the U.S. Coast Guard took over operations of the light.

It is no surprise that over 15,000 visitors flock here each year. Located on a bluff overlooking Lake Ontario, the light-house grounds offer a spectacular view not just on a clear day and at sunset, but also when the lake is in its full fury during a storm, with waves pounding the shoreline. The Tibbetts Point Lighthouse Historical Society was formed in 1988 to preserve and maintain the lighthouse, keeper's house and grounds. In 1994 the society built a visitors' center and museum, which is owned by the Town of Tibbetts Point. During the summer months, the lighthouse keeper's cottage is a youth hostel that invites youth from around the world to imagine what it would be like to be a lightkeeper for a night. GF

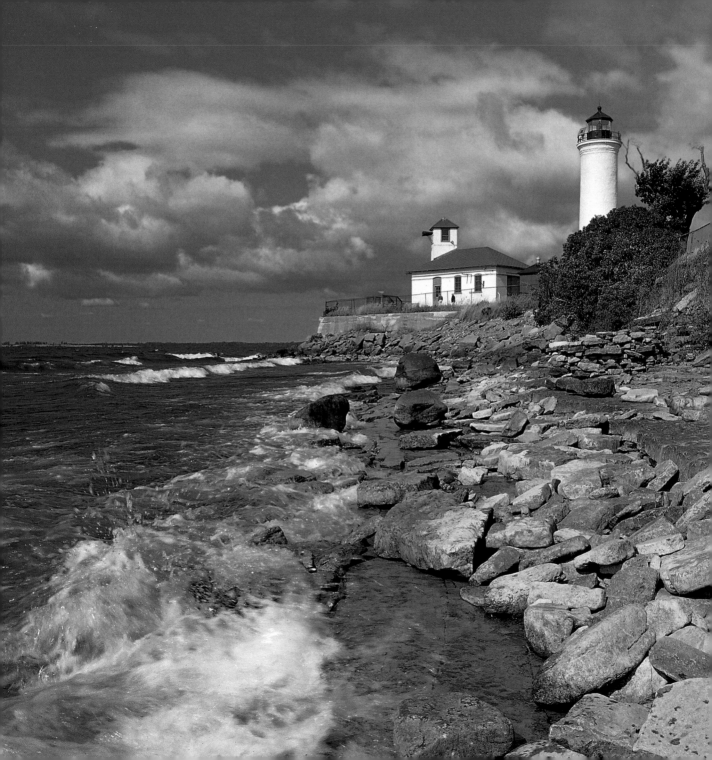

Pigeon Island

L ying 4 miles (6.4 km) from the west head of Wolfe Island and a million miles from nowhere, Pigeon Island is a tiny speck of land in Lake Ontario at the Canadian entrance to the St. Lawrence River. It would seem that it should have been named Gull Island instead of Pigeon, for the gull colony that currently inhabits this otherwise undisturbed islet, but at one point it was probably inhabited by passenger pigeons.

Built in 1871, at a height of 65 feet (20 m), the white lighthouse is a square steel skeleton tower surmounted by a white wooden watchroom and a red circular metal lantern. A red cylindrical steel tube enclosing the staircase extends from the base of the tower to the watchroom. On a clear day the light is visible 13 miles (21 km) out into Lake Ontario.

J.H. Davis was appointed the lightkeeper of Pigeon Island on May 16, 1896, at an annual salary of $420 per year. During periods of heavy fog, Mr. Davis warned approaching ships of the perilous shoals by manually squeezing a foghorn (he had to have pretty strong arms). The lightkeeper lived in a 1 1/2-story wooden dwelling with four rooms, and there was a small boathouse for the boat that in the 1800s provided the only means of travel to and from the island

Rebuilt in 1909, the lighthouse saw active service until 1957, when it was demanned. In 1963 the lightkeeper's house and boathouse were considered surplus and bids were received to dismantle the structures. Howard Orr, a former lightkeeper of Nine Mile Point, put in a bid of $200, but the properties were sold to Nelson Eves on the condition that he dismantle and remove the buildings from the island.

From 1964 to 1974 Pigeon Island was occupied by various colonies of bird species and the occasional human species, such as the Canadian Coast Guard in Prescott, Ontario, but not much occurred on Pigeon during the years after the buildings were removed. In 1974 the Canadian Wildlife Service asked the Coast Guard not to disturb the bird colonies during nesting season, between April 26 and August 31. At the time of the request, the island was home to 60 pairs of herring gulls, 150 pairs of captain terns and 2,000 pairs of ring-billed gulls.

Today, Pigeon Island is accessible only by helicopter on the regular maintenance runs from the Prescott Coast Guard base. On a foggy, late October afternoon, I boarded the red-and-white Coast Guard helicopter along with 20-year veteran pilot Michel Fiset. Within 25 minutes we had passed Kingston and soon the western point of Wolfe Island. Just past the horizon, I could make out the skeleton tower on Pigeon Island. Three rays of sunlight burst through an otherwise cloudy gray sky. We landed briefly on the island to perform routine checks on the light before returning to base, leaving the island to its permanent inhabitants, the gulls. GF

Sentinels in the Stream

Nine Mile Point

Nine Mile Point lighthouse, on the southwest point of Simcoe Island, is only 9 miles (14.5 km) west of Kingston, but it is truly an adventure getting to this remote light. A 25-minute ferry ride from Kingston to Wolfe Island is followed by a 10-minute cable ferry to Simcoe Island (also known as Gage Island). The narrow dirt road from the ferry landing on Simcoe Island leads west about 4 miles (6.4 km) to the lighthouse, where the road ends.

According to Coast Guard records, the light was built in 1833 on land bought from William Breden for $600. It is a wonderful example of an Imperial light, the common style from 1830 to the 1860s. This lighthouse features a circular tower made of rubble stone approximately 2 1/2 feet thick (.8 m), a wooden spiral staircase of 48 steps, and a system of weights used to rotate the beam from a Fresnel light located at the top of the 40-foot (64 m) tower.

Stannes Veech was paid the princely annual salary of $800 to watch over the light in 1894. As part of his duties, he was required to hand-crank the system of weights and cogs every several hours to ensure that the light revolved continuously. This of course was not condusive to getting a good night's sleep, but more irritating was the new foghorn, built by William Ashe of Ottawa to replace the 1,000-pound (454 kg) fog bell. The foghorn was operated by compressed-air and gave one blast of seven excruciatingly long seconds every minute during a fog. So between the foghorn and the cog-operated weights, Nine Mile Point was not a posting that afforded the lightkeeper a peaceful night's rest!

The original Fresnel light threw a flashing white beam over 12 miles (19 km) into Lake Ontario. The foghorn was discontinued in 1991 when the station was downgraded by the Coast Guard to pleasure craft status. The Fresnel light was replaced with a smaller beacon in 1994.

The last lightkeeper at Nine Mile, Robert Corcoran, retired in 1987. In 1989 the Federal Heritage Review Board designated the tower as a Federal Heritage Building and a gravel road and helipad were built to service the light. In 1992 Rune Bruteig, an aspiring filmmaker from Toronto, shot an eerie, avant garde, black-and-white film called *Trouble at Nine Mile Point* at the lighthouse. Nine Mile Point is also a graveyard for many ships that were scuttled off the point. The only known fatality, however, was that of 76-year-old Captain McIvor, who perished when the 171-foot *Aloha* collided with the *Effie Mae*. Both vessels lie in 55 feet (17 m) of water and are a popular site for divers.

The land and buildings adjacent to the lighthouse are now on private property, as I discovered when I arrived at the large iron gate at the end of the road. The current owners, Terry Clar and Mary, Kevin and Lisa Miskell, Americans from nearby Rochester, don't mind sharing the lighthouse with inquisitive lighthouse addicts as long as you are mindful of the fact that you have to cross their property to get to the Coast Guard right of way and the lighthouse itself. Please ask to visit before you proceed onto the property. GF

East Charity Shoal

The East Charity Shoal lighthouse is visible from Tibbetts Point on a clear day with a set of binoculars. It's located 7 miles (11 km) out onto Lake Ontario from Cape Vincent, and the only way to get there is by chartered boat on a calm day — or if you have a Canadian Coast Guard helicopter and pilot at your disposal.

Standing 35 feet high (11 m), the East Charity Shoal lighthouse was once the subject of a baffling mystery. In 1929 a massive ice storm descended on Lake Erie near Vermilion, Ohio, and caused extensive damage to the Vermilion Station light. Concerned about the danger that the damaged lighthouse posed to navigation, Coast Guard officials had it removed by barge to Buffalo, where the light was dismantled, repaired and a fifth-order Fresnel light installed. Ready to return to service, the lighthouse was reconstructed, but on East Charity Shoal, a dangerous set of submerged rocks near Cape Vincent and the entrance to the St. Lawrence River on Lake Ontario — not at Vermilion, Ohio, on Lake Erie. The citizens of Vermilion lost their lighthouse.

One day in September 1994 a resident of Vermilion read an article in a local newspaper about the East Charity Shoal lighthouse and saw a photograph. He immediately recognized the lighthouse as the one that had gone missing from Vermilion Station, and the 65-year-old mystery was solved.

Today the light is still in active service, winking regularly to its nearby cousin lighthouse on Pigeon Island, on the Canadian side of Lake Ontario. GF

Rock Island

S hips traveling up the narrows, where the river tapers to its narrowest point on the Seaway, pass within 50 feet (15 m) of the Rock Island light. The first lighthouse was built here in 1847 as an aid to navigation through the obstacle course of rocks and shoals.

The *A.E. Viceroy*, a three-masted wooden schooner, struck a rock while entering the American narrows on August 17, 1889. The crew abandoned ship and sought refuge at the Rock Island light. Later, a large steamboat hit the shoals near the island, and it was decided that a new, more visible light was needed on Rock Island. Unfortunately, the light was erected in the center of the island and was difficult to see.

In 1882 a 40-foot-tall (12 m) second lighthouse was built at the end of a man-made stone pier, with the base of the light jutting about 30 feet (9 m) into the channel. The original iron lantern house and sixth-order Fresnel lens from the old light were installed in this lighthouse.

Bill Johnston was appointed lighthouse keeper in 1852. He had taken part in the 1838 Patriot Wars, but his side had lost, and he had been imprisoned. Following his pardon, he began a new life as lightkeeper of Rock Island. The last lightkeeper on Rock Island was Frank Ward, who served from 1939 to 1941, when the light was deactivated.

Fishers Landing or the community of Thousand Island Park on Wellesley Island are great places from which to view the light. Now part of a New York State Park, the location offers quite a number of fascinating sights, such as a carpenter's shop built in 1882, a boathouse built in 1920, and the rusting hull of a ship wrecked on a nearby island. There is also an awesome view of the Thousand Islands International Bridge about a mile (1.6 km) further east along the river. The 4,500-foot (1,370 m) suspension bridge was officially opened in 1938 by Canadian Prime Minister W. L. Mackenzie King and American President Franklin D. Roosevelt. GF

Sunken Rock

Just outside the marina at Alexandria Bay, an extremely dangerous set of shoals lurks beneath a couple of feet of water, posing a menace to large ships entering the narrows on the American side of the Seaway. A lighthouse was built here in 1847 on Sunken Rock Island, or Bush Island as it was originally called, and was rebuilt in 1855 to a height of 40 feet (12 m) and capped with a beautiful sixth-order Fresnel light. The light was converted to use solar energy in 1988 by its owners, the St. Lawrence Seaway Development Corporation.

The lighthouse has been the site of many tragedies over the years — lost lives and lost loves. On September 15, 1909, the *Islander*, a wooden steam sidewheel vessel, sank in 60 feet (18 m) of water, joining the schooner *Catharine*, which sank in 1890. On the night of November 20, 1974, tragedy struck again. The *Roy A. Jodrey*, a 641-foot freighter, struck Pullman Shoal at around 11:00 P.M. The ship struggled to stay afloat for four hours but finally sank at 3:20 the next morning in 240 feet (73 m) of water. Fortunately, the U.S. Coast Guard rescued all 29 crew members.

Another sinking occurred in 1904, but this was a different sort of sinking, a sinking of the heart. Wealthy American George C. Boldt, owner of the Waldorf Astoria Hotel in New York City, had purchased Heart Island in 1900. The island, located just off Alexandra Bay and only a few hundred feet from Sunken Rock Island, was to become the site of a magnificent castle, with 120 rooms, drawbridge, yacht house and Italian-style gardens. It was to be built as a testament of Boldt's love for his wife, Louise. In 1904 Louise died suddenly. George, brokenhearted, could not conceive of his dream castle without his beloved and vowed never to return to it. The castle remained vacant for over 75 years until it was purchased and restored. Boldt Castle now welcomes over 250,000 visitors each year aboard the many pleasure crafts and scenic tour boats that ply the waters of the Thousand Islands. GF

Sisters Island

I f you happen to go for a swim off the north end of privately owned Sisters Island, you'll be swimming in Canada. If you take a dip from the south end, you'll be swimming in the United States. Situated on the American side of the St. Lawrence, Sisters Island is on the imaginary boundary line that separates the two countries.

Arthur Frank Jr. operates Thousand Islands Aviation Services from his Maxon Air Field in Alexandria Bay. Although I spent several hours flying with him and photographing nearby lighthouses, he offered to take me to Sisters Island aboard his beautifully restored wooden motorboat.

On a cold, clear October morning we headed upstream to photograph the Sisters Island lighthouse. The tip of Grenadier Island, on the Canadian side, is only 13 miles (21 km) from Alexandria Bay. Arthur maneuvered the boat alongside a buoy opposite Sisters Island, and we patiently waited as a huge freighter passed through the channel, its bow creating a 6-foot (2 m) wake.

The gray limestone and brick lighthouse was built in 1870 to mark a precarious spot on the Canadian side of the channel, but after the lighthouse was commissioned, the channel was moved to the American side. It was common in those days to have to blast and drill to deepen the narrows to the required depth of 27 feet (8 m) so that freighters could pass. At nearby Cockburn Island, the drill barge *J.B. King,* with a crew of 43 on board, was drilling holes in the bedrock at the bottom of the river when lightning hit the ship and a connecting wire became a conduit to the 1,500 pounds (680 kg) of dynamite that had been placed by divers. An immense explosion followed, killing all but 11 of the crew, who were saved by the U.S. cutter *Succor.*

The first lightkeeper at Sisters was Captain William Dodge, who was followed by his son. Between them they manned the light for a total of 51 years, until 1921. In the beginning, Bill Dodge and his family were required to spend the entire year maintaining the 60-foot (18 m) light, despite the fact that the light was extinguished during the winter months, when the St. Lawrence froze over. Later, after his son took over, the light was closed in November and the keeper and his family were allowed to return to the mainland until spring thaw.

In 1959, when the St. Lawrence Seaway opened, the lighthouse was replaced by a buoy marking the channel, and the light fell into a state of disrepair and neglect. In 1967 it was sold as Coast Guard surplus to Alfrieda and Edward Lovos, who have painstakingly restored it to its former glory. GF

Crossover

S hips sailing down the Seaway to the Great Lakes crossed over from the Canadian side of the channel to the American side at Crossover light, hence the name Crossover Island. The original lighthouse was built in 1848 and painted brown. It was rebuilt in 1882 and strengthened to withstand the harsh winds and hard winters on the St. Lawrence. The light was then repainted white, the standard color commissioned by the U.S. Coast Guard at the time, and relocated about halfway between Alexandria Bay and Morristown. The light can be viewed and photographed easily from the Scenic Highway on the U.S. side, but though it is an American light, it is only 1,000 feet (300 m) from the Canadian side of the river yet a mile (1.6 km) from the U.S. mainland.

The first lightkeeper on the island was a Mr. Robinson. He was succeeded by Daniel Hill, who operated the light from 1909 to 1931. It was a busy posting for Hill, who was responsible for the rescue of several hundred lost, shipwrecked or marooned mariners. He was also responsible for saving the lives of three passengers aboard an ill-fated plane that crashed in the river near the light. When he was ready to retire from active service, he handed over the reins to his son Ralph, who proudly followed in the footsteps of his father. The lighthouse is often called the Ralph Hill Lighthouse in honor of him.

On November 21, 1941, a year before the lighthouse was decommissioned, it was the site of the sinking of the *Daryaw*, a 219-foot freighter built in France. The ship struck a shoal near Crossover, creating a huge gash in its starboard side. Fortunately, the crew were able to evacuate in lifeboats and no lives were lost.

In 1969 the island, including the lighthouse and buildings, were sold to Betty Jo and Maynard Dutcher, who maintain the property as a private dwelling. GF

Prescott Harbor

It was Ted Cater, the marine navigation officer in Prescott, Ontario, who explained to me the Fresnel light system used in many lighthouses around the world. Prior to that, I didn't know the difference between a Fresnel light and a flashlight. The Fresnel lens was invented by Jean-Augustin Fresnel, a French physicist born in 1788, in Normandy, France. The Fresnel system involved a combination of separate highly polished lenses and prisms that concentrated the light source to create an intense ray of light that could be seen for up to 25 miles (40 km) away. The first lenses that Fresnel invented were categorized as a dioptric system using lenses and prisms. He later made modifications to this system by adding reflectors to increase the distance the light could be seen. This was called a catadioptric system. In the 1820s the Fresnel lights were shipped throughout Europe and North America and were carefully reassembled in each lighthouse. Each Fresnel light was a work of art. They were made in various sizes or "orders." A first-order Fresnel light was the largest at approximately 6 feet high and 10 feet wide (2 m x 3 m). It could send a beam of light over 20 miles (32 km) to sea. Smaller orders, from two to six, were less powerful, smaller and less weight.

Why do I go into such detail about the Fresnel light, you may ask. The Prescott light is a beautiful example of a fifth-order lens. The lens itself was used as a training light and was mounted atop the old Precott Coast Guard building. When the building was rebuilt, the Coast Guard donated the light to the Rotary Club of Prescott. In 1989 the Rotary Club built a 40-foot (12 m) replica of a lighthouse to function as a tourist information center and ice-cream store. Although the Fresnel light no longer shines, you can make out the intricate array of lights and prisms quite easily as you stand outside the structure, which sits at the foot of water street facing the Prescott harbor. GF

Windmill Point

A very peculiar lighthouse, the Windmill Point light began its life in 1822, the year it was built by a West Indian man named Hughes to function as a stone windmill to crush wheat into grain. It's hard to imagine that this tranquil spot, with its carefully manicured lawn and picturesque view of the St. Lawrence River, could have been the site in November 1838 of a bloody four-day skirmish between 200 Americans, sympathetic to political reform in Canada, and local Canadian militia and British soldiers. The "Battle of the Windmill," part of the Patriot Wars, took place because "patriots" in the United States were convinced that Canadians wanted to be free of their British "oppressors." These patriots frequently made raids across the St. Lawrence River to try to "free" the Canadians. In the end, 14 Canadians were killed in the Battle of the Windmill and 67 wounded.

In 1874, thirty-six years after the bloody battle, the windmill began a second, more peaceful life, saving people, after being transformed into a lighthouse and an aid to navigation on the Upper St. Lawrence River. The huge limestone tower was purchased by the Canadian government and a minuscule red lantern house, somewhat out of place, was constructed atop the over 80-foot (24 m) structure

According to Coast Guard records, the light was purchased by the Department of Northern Affairs on December 10, 1964, to develop into a national historic site. On January 2, 1979, the light was extinguished. But 18 years later, in the summer of 1997, the lighthouse began another life, as a museum operated jointly by the Friends of Windmill Point and Parks Canada. Located just a mile or so east of Prescott, in a tiny hamlet called New Wexford, the lighthouse commands a stunning view from its perch on a bluff 20 feet (6 m) above the mighty St. Lawrence River, opposite Ogdensburg. In the distance you can see the pillars of the Prescott–Ogdensburg bridge that connects the U.S. and Canada. During the summer months, you can climb to an observation level just below the light and perhaps even imagine what it was like to be in battle on these very grounds. GF

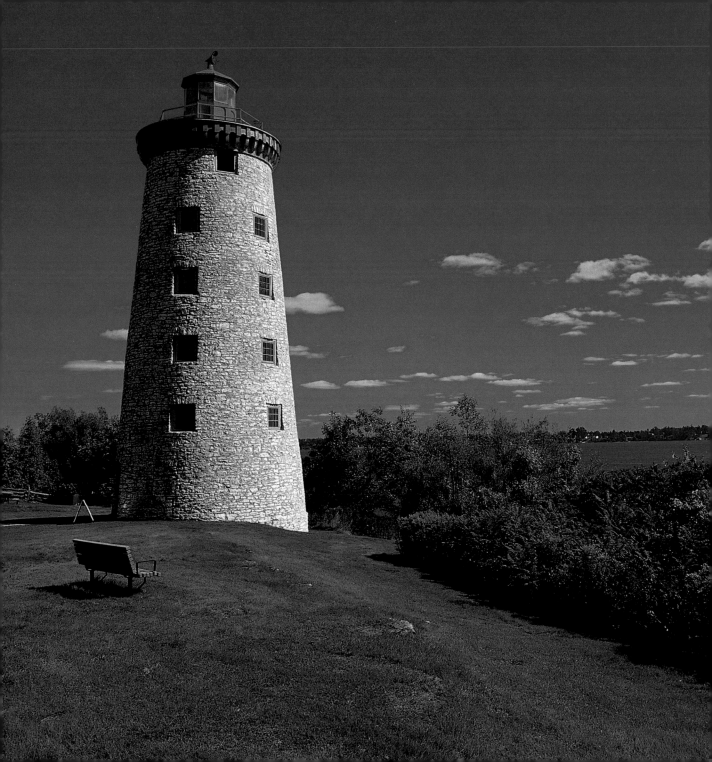

Île-aux-Coudres

From the Île-aux-Coudres ferryboat at Saint-Joseph-de-la-Rive, you can see the lighthouse emerge from shoals upstream of the island. Once off the ferry, turn right on the road toward Saint-Louis de l'Îsle-aux-Coudres. There, you will see the island's famous windmills, one of the nicest churches in Québec, little sideroad chapels, and the house of Claude Bouchard, who arrived in 1650 with his brother Nicolas, my ancestor. To be honest, I had you make a detour. You could have observed the lighthouse from the lookout off the cycling path between Saint-Bernard and Saint-Louis. In spite of its two upper floors and its dome, the lighthouse must seem tiny to the ships that go through the north channel and the mountains of Charlevoix surrounding Baie-Saint-Paul.

The pillar light was built between 1950 and 1952 and received power through an underground electric line. No keeper was ever assigned to it. The top part of the dome is used as a helipad, but has become a favorite perch for cormorants.

A lightship was used before the pillar light. The men lived aboard the anchored ship for three navigation seasons, in constant dampness, with the odour of kerosene lamps and the constant rocking of the waves.

Today, kayakers enjoy stopping here after going around the island. Nature lovers can reach the light by crossing the sandbars at low tide or by Chemin des Marais on the north shore, just before Saint-Louis. Along the way, you will come across winkles, cormorants, eider ducks and scoters. CB

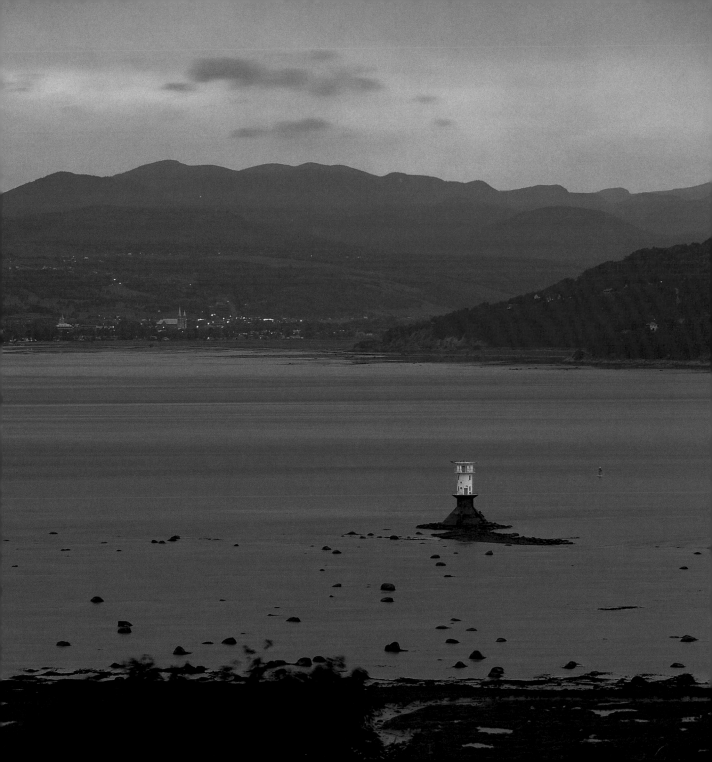

Cap-au-Saumon

Cap-au-Saumon lighthouse stands on Pointe-des-Rochers, on the coast of Charlevoix, a short distance west of Port-au-Persil. The path starts almost at the top of the mountain, beside an old abandoned henhouse near the west entrance to the hamlet. Walking in the morning dew can be a pleasant experience, but the latter part of the walk was not as enjoyable as the initial stretch. The electric line that powers the lighthouse follows the cliffs along the coast, and I can't recommend the path to children or slightly overweight photographers carrying 30-some pounds (15 kg) of equipment. Fortunately, the luscious blackberries along the path and the whales lazily following the coast kept me going. After a two-and-a half-hour walk on top of the headland, there it was.

From the top of the 46-foot (14 m) octagonal cement tower, covered with white roughcast, the Cap-au-Saumon light sent its own code: two flashes interrupted by three-and-a-half-second eclipses, followed by another flash and a last eclipse of 13 seconds. With the Cap-de-la-Tête-au-Chien lighthouse, it guided ships passing through the channel between Île-aux-Lièvres and the rugged coast of Charlevoix. Under foggy conditions, a foghorn would signal the presence of the reefs with a sequence of three calls of two seconds, interrupted by two silences of three seconds, and ending with a long silence of 48 seconds.

The original wooden lighthouse was built in 1894, then replaced with the current lighthouse in 1955. The keepers and their assistants led a reclusive life, as there was no access by land, and strong winds and bad weather frequently made it difficult to come ashore. In addition to keeping the lighthouse, the men had to take care of the outbuildings, the boardwalk and the hoist. Toward the end the light's manned period, the use of a helicopter reduced the keepers' isolation. The lighthouse was automated in 1980.

The houses of the keeper and his assistant still stand on the site, along with two sheds, still in good condition. The Cimevir organization now operates the light. Carriers from La Malbaie or Tadoussac ferry visitors near the lighthouse, but the cape is reached aboard a smaller craft. There is also a landing at Port-au-Persil, quite close to the site, where boats can dock.

My walk was a memorable one. As I stopped atop the cliff, the lighthouse and its freshly restored buildings stood out against the river as it flowed through the Lower St. Lawrence region, and further on the horizon, the foothills of the Appalachians reflected in the blue water. Below me a humpback whale saluted before diving into the whitecaps, and in the distance, a few belugas.... CB

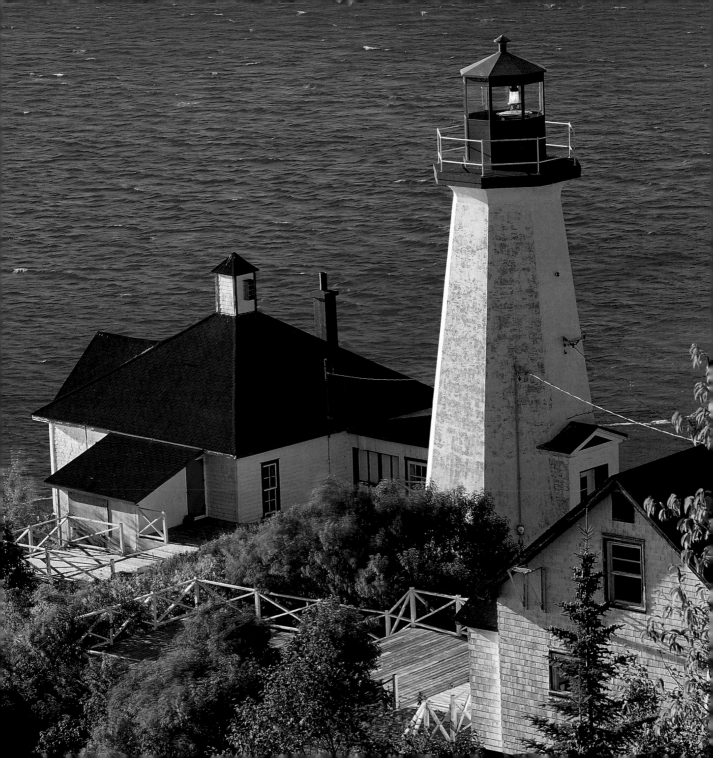

Cap-de-la-Tête-au-Chien

On the ferry from St-Siméon, in Charlevoix, to Rivière-du-Loup, passengers will see, to the left, on a rocky headland, an intermittent flash every four seconds. It is the light of Cap-de-la-Tête-au-Chien (Cape Dog's Head), one of the most isolated coastal lighthouses on the St. Lawrence.

The 39-foot-high (11.8 m) lighthouse stands against a cape more accessible to climbers than to hikers. The best way to see the lighthouse, I think, would be to rent a boat in one of the loveliest bays on the St. Lawrence, Baie-des-Rochers, a short distance downstream. However, two obstacles remain: the tide and the wind. It is obvious why they call it Baie-des-Rochers (Rocky Bay). On our first attempt, the wind and rocks kept us from proceeding safely in our flat-bottom boat. Our second attempt was fruitful. Bertrand Desbiens, of Baie-des-Rochers, took us in a faster, more suitable boat. His brother had been a keeper at the Cap-d'Espoir, Tête-au-Chien and Île-Rouge lighthouses. On our way to the light, a fin whale passed close by.

We boarded the cape, and I climbed, carefully clutching the rocks, until stairs appeared. Three hundred and twenty steps! They had not been maintained since 1943. The handrail was more of a psychological aid than a practical one, and I put my foot close to the beams that held the rotten steps — through which I could see, 16 to 20 feet (5-6 m) below, the parent rock of the Canadian Shield. A winch alongside the stairs was used to hoist the provisions to the lighthouse and its occupants. The last keeper's residence was built in 1956 and his assistant's in 1961. The lighthouse was built in 1909 and remains unchanged. A smaller octagonal tower supports a big red lantern with a strong dioptric lens that spreads its guiding light over the St. Lawrence. The last keepers left in 1988.

I had noticed, on my first visit, that bundles of wood had been airlifted onto the rocks. A month later, I returned to the lighthouse aboard a Canadian Coast Guard helicopter with a team of workers who were on their way to rebuild the stairs. CB

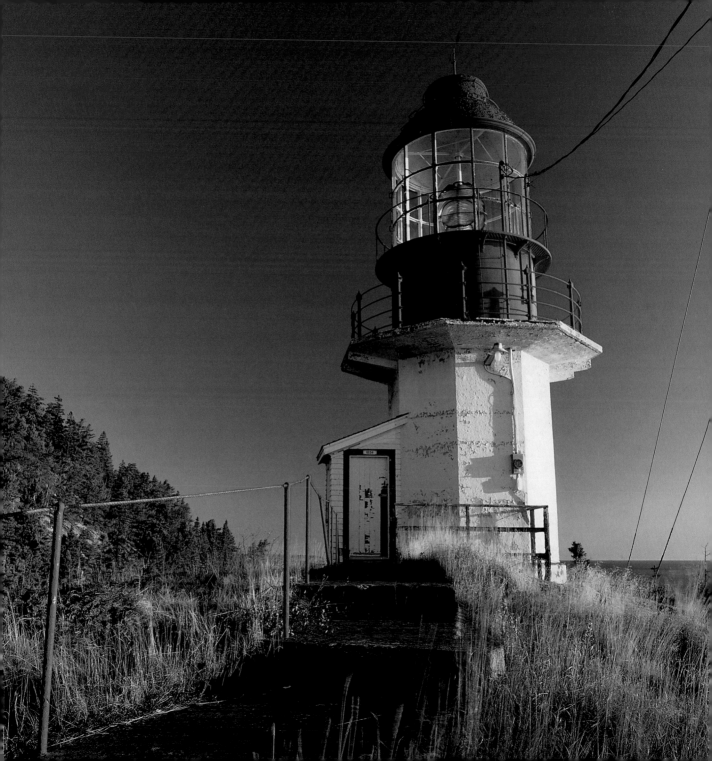

Prince Shoal

O n August 18, 1860, with His Royal Highness the Prince of Wales, the future King Edward VII, on board, the H.M.S. *Hero* ran onto the shoals off Tadoussac. They did not appear on the Admiralty's maps. Her Majesty's cartographers named the location the "Prince Shoal" (Haut-Fond-Prince in French).

The lighthouse was built in a dry dock in 1962 then conveyed to its actual site in 1964, where a bed of 2,400 tons of rocks had been prepared. Girders were driven 30 feet (9 m) into the sea floor to sustain the structure and 24,000 bags of cement were poured into its base. The structure was built to resist 25-foot (8 m) waves, even if they rarely reach higher than 15 feet (4.5 m). In addition to housing the dwellings and engine rooms, the light was equipped with a motorboat and a helipad. At 82 feet (25 m), the light had a range of 35 miles (56 km). Three foghorns insured the security of vessels navigating the mouth of the Saguenay.

On December 25, 1966, three keepers, Roger Lagacé, Claude Fraser and Yvanohé Gagnon, were on duty. At 4:00 A.M. Lagacé took his watch. It was snowing hard, then the wind rose, and with the high tide, the sea swelled. An hour later, a 2-inch-thick (5 cm) steel door was battered down at a height supposedly unreachable by the waves, and water started pouring in by the emergency stairs. By 8 o'clock the waves had reached 42 feet (13 m) and broken the window of the room under the helipad. The keepers contacted the Canadian Coast Guard by radio and asked to be rescued by boat or helicopter, but conditions were too bad. By 11:00 A.M. all the lower windows had been shattered, water had filled the furnace room, cutting off the heating, and the sea was still rising. At noon, the wind registered 85 miles per hour (137 kph), the maximum the gauge could indicate! The men took refuge in the boiler room, the only place where they could get a bit of protection, but the water kept seeping in through the tower and the helipad. The pillar was cracking. This was the end.

Around 9:00 P.M. water stopped seeping in, and by midnight the storm had died down. The men ate what was left of their Christmas dinner.

The break of dawn on December 26 exposed the giant gap in the east wall, opening onto the St. Lawrence, the ruined floors of the dwelling, torn lamps, the broken structure of the tower, and the twisted girders between the base of the pillar and the top. Everything was covered in ice. In the afternoon, a helicopter was able to rescue the lightkeepers.

The pillar light was repaired, but of the three keepers, only Gagnon kept on working at Prince Shoal, staying on until 1981. The light was automated in 1987. CB

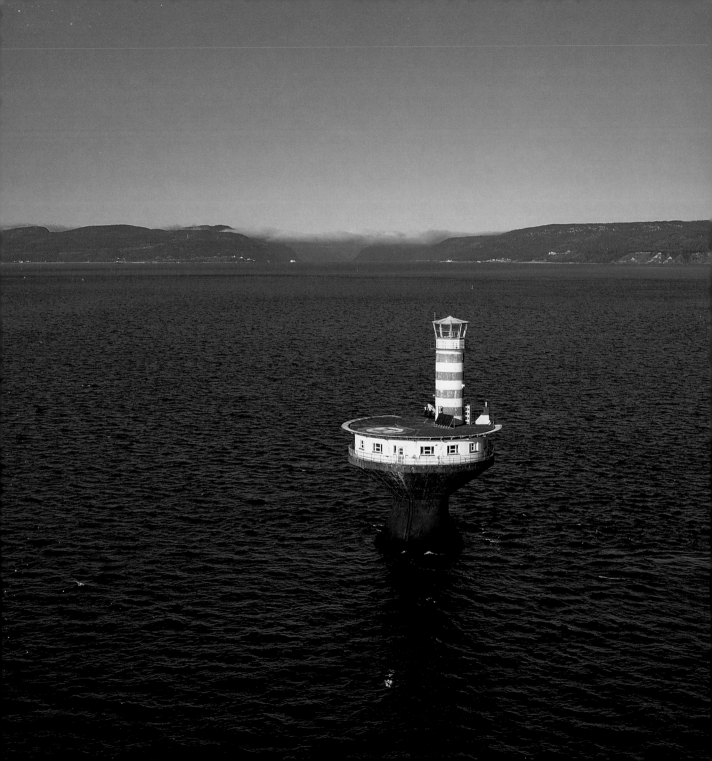

Cap-de-Bon-Désir

B etween Tadoussac and the Escoumins, near Grandes-Bergeronnes, Cap-de-Bon-Désir lighthouse stands atop a headland, visible only from the river. This lighthouse was built after the erection, in 1941, of a 31-foot (9.4 m) steel skeleton to support an acetylene lamp. The octagonal concrete tower was designed in 1958 to support a dome, adding as much as 50 feet (14.3 m). The light was first powered by a 500-watt electric bulb and later by a 250-watt mercury-vapor bulb directed by two 10-inch Fresnel lenses.

Gilbert Fraser was chief keeper from 1958 to 1975. He had two assistants, Lucien Dionne and Charles Eugène Bouchard. Fraser was replaced by Marcel Ouellet. The lighthouse was automated in 1982.

In 1958 the diaphone sounded during five seconds every 40 seconds. In 1971 the new electronic foghorn sounded four seconds every minute.

During the summer of 1999, I was asked to photograph the whales off Cap-de-Bon-Désir with the tourists looking on. The embankment where the lighthouse stood was covered with fireweed. The light was diffuse, and below the cape we could hear the whales blowing, echoing the foghorn, as they passed. Around the middle of the nineteenth century, the first shipboard foghorns, steam whistles, frightened many inhabitants along both shores of the St. Lawrence. People thought a huge monster roamed the waters. It's said that a particular tugboat pilot took pleasure in terrorizing the coastal villages.

The only beast that we could hear in the area was the fin whale. My photography session came to an end when the mist changed to fog and then to torrential rain. GREMM, the research group on marine mammals who runs Cap-de-Bon-Désir, also hosts a presentation on great sea mammals, including the piked whale, the fin whale, the humpback whale and the blue whale, which can be seen here on clear days. CB

Île du Pot-à-l'Eau-de-Vie

B iologist Jean Bédard greeted me with a firm handshake and a big smile when I first met him on a cloudy summer morning. The season was drawing to a close and he offered to let me spend a night in the lighthouse that he, along with the Duvetnor firm, has saved and transformed into an inn.

Later that day, I left Rivière-du-Loup on a Duvetnor boat with three tourists from Ontario. The captain and the guide entertained us with notes on the history and the wildlife of the islands of Pot-à-l'Eau-de-Vie and Île-aux-Lièvres.

The Pot-à-l'Eau-de-Vie Islands, which link up at low tide, got their name while under French rule. The reddish brown color of the rainwater retained by the rocks looked like brandy to the sailors, and the shape of the rocks like brandy pots. It is quite probable that during Prohibition bootleggers hid alcohol in a depression located behind a cliff on the north shore of the bigger island. The area is invisible from the south shore and is also hidden from the people of Charlevoix, on the north shore, by Île-aux-Lièvres.

In 1740 the Royal vessel *Rubis* was forced to stop at the island when its passengers and crew members were struck with fever. Forty-seven later died at the Hôtel-Dieu Hospital in Québec City. The *Endeavour* ran aground at the beginning of winter in 1835. Captain Lachance made a fire on the island's highest point and kept it going until it was seen from Rivière-du-Loup by Joseph Pelletier. Pelletier organized a rescue expedition and convinced seven men to paddle two canoes the 12 miles (19 km) to reach the island, but by the time they arrived, 14 men had died of exposure and starvation. The reefs and shoals of the south channel are particularly dangerous. There were other shipwrecks, including the *Universe* in 1845 and the *Salisbury* in 1846.

In 1862 another kind of flame appeared on the headland of the smaller island: atop a 30-foot (9 m) tower stood a 9-foot (3 m) dome with its lantern and weathervane. The brick tower was erected in the center of the keeper's house. A warehouse, a landing and a winch were later added to the station and a gallery and stairs were added to the house.

The lighthouse was automated in 1964. In 1975 a metal structure replaced the old light, and three years later the lantern was removed from the dome. Today, the lighthouse is a historical site, an architectural attraction and, as an inn, a gastronomic experience. CB

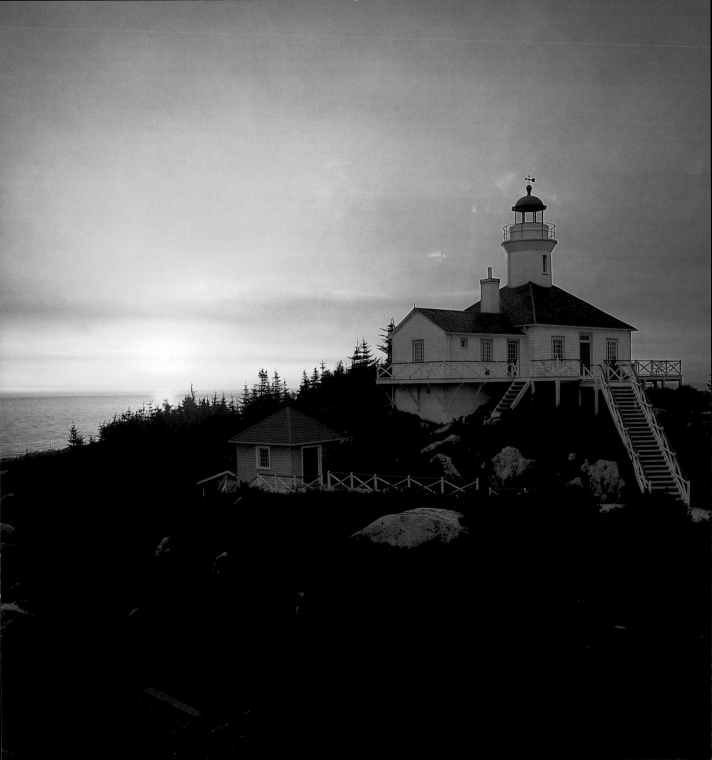

Île-Rouge

Trinity House was created in Lower Canada in 1805 to organize, facilitate and monitor maritime transportation in the St. Lawrence from the fifth rapids upstream from Montréal to its mouth in the gulf. Around 1840, Trinity House faced a challenge other than the St. Lawrence's bad weather and natural obstacles. The opening of the maritime seaway on the Hudson River, and the construction of the Champlain and Erie canals, favored the harbor of New York City over that of Montréal. In an attempt to ensure the domination of the St. Lawrence as a seaway, Trinity House built the lighthouses of Pilier de Pierre and Île-Bicquette in 1843 and of Île-Rouge in 1848. These were areas of great navigational danger. Île-Rouge had accounted for 32 shipwrecks since the beginning of French colonization. The strong currents and the shoals northeast of the island are particularly dangerous.

The tolls collected by Trinity House enabled them to use the best building materials and hire the most qualified contractors and craftsmen. The stones of the exterior wall of the Île-Rouge lighthouse were to be of the same quality as those of the French cathedral of Montréal and were probably imported from Scotland. Inside, a wall of the best English-made bricks was built to cover the stone. A masonry arch supported the dome, and between each of the tower's four stories, three stone arches drove the rain away from the wall so the stones would stand the test of time. The Île-Rouge lighthouse is an architectural marvel.

The 60-foot (18 m) lighthouse has required only minor repairs to its stonework and remains very nearly in its original condition. During the summer months, Île-Rouge becomes a bird sanctuary for herring gulls and great black-backed gulls and is accessible to visitors only when the nesting period is over. The last keeper left the island in 1988. The Cimevir group, based in Tadoussac, now offers package tours that include a tour of the island and accommodation in the houses adjoining the lighthouse. CB

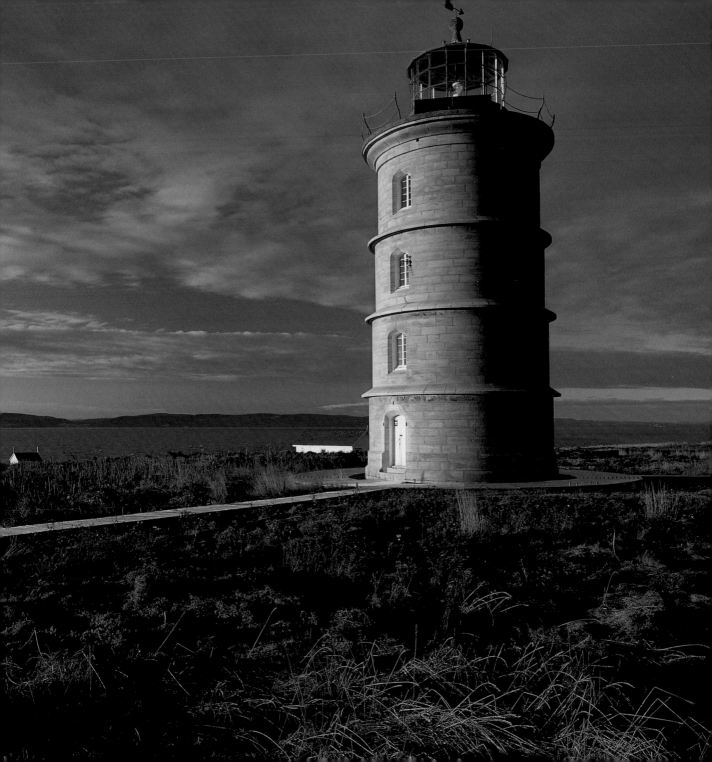

Île-Verte

I f the lighthouse at Île-Verte looks familiar to you, its probably because you have licked it! On September 21, 1984, on the 250th anniversary of the completion of the first lighthouse in Canada, at Louisbourg, Canada Post issued a commemorative set of stamps depicting Canadian lighthouses. Île-Verte was one of four stamps designed by Toronto artist Dennis Nobel.

Île-Verte is the third oldest lighthouse in Canada and the first built on the St. Lawrence River. Built in 1809, it remained the only light on the St. Lawrence until 1830. It is located on the northeast tip of Île-Verte, perched on a rocky outcrop. On a clear day, you can easily see the city of Tadoussac on the other side of the river, where the Saguneay River joins the mighty St. Lawrence.

To reach Île-Verte I drove about 20 miles (32 km) east of Rivière-du-Loup and arrived just in time to miss the ferry boat, *La Richardiere*, for which reservations are recommended in summer. Luckily for me, Jacques Fraser operates a boat taxi service to the island aboard the motorboat appropriately named *Jacques Fraser I*. The only problem is that because the St. Lawrence River is so shallow between the mainland and Île-Verte, I had to wait until high tide to cross the 3-mile (5 km) distance.

Signs at the wharf indicate the direction to the lighthouse, which is about a 45-minute walk along a quiet dirt road. The island has been described as an "island of dreams," "an oasis of silence" and a "virginous verdant forest." I must say that all these descriptions proved true. The lighthouse itself is a massive circular stone structure 56 feet high (17 m), painted white and capped with a 12-sided red lantern house. Its flashing white mercury-vapor light can be seen for 15 nautical miles.

Six lightkeepers and their families were the guardians of the light for over 163 years, until its automation in 1972. Charles Hambleton was the very first lightkeeper, followed by Robert Lindsay in 1827, whose family and descendants kept the lighthouse vocation in their blood until 1964. Armand Lafrance, the last lightkeeper, left in 1972 to become the guardian of the Pointe-au-Père lighthouse. In 1974 the light was designated a national historic monument, and more recently it has become a bed-and-breakfast and museum.

The top of the lantern house offers a magnificent view of the St. Lawrence, and blue whales, belugas and pilot whales can all be seen with the naked eye. The light can also be reached via the Internet at www.ileverte.tripod.com, where you can get a virtual tour of the island, including a 360-degree view from the top of the light. GF

Île-Bicquette

Île-Bicquette is a tiny islet off the coast of the famous Bic Conservation Park, smack in the middle of the St. Lawrence River. The park was opened on October 17, 1984, with the purpose of protecting the flora and fauna of the St. Lawrence estuary. Reaching this lighthouse is no easy feat. It's a wet, bumpy one-hour ride in a Zodiac boat from the Bic harbor. Located on the northwest side of Île-Bicquette, and just north of a larger island called Île-du-Bic, the light was built in 1844 and modeled after the light at Île-Verte. The round white lighthouse reaches a height of 75 feet (23 m) and has a mercury-vapor dioptric light. The flashing beam can be seen by ships for up to 17 miles (27 km).

In a catatropic light, reflectors are used to intensify the beam. A silver metal reflector is usually placed behind the lamp. In an arrangement such as this one, not only is the light source itself visible at sea, but the reflector captures the light that would otherwise be lost behind the source light. However, a catatropic system is not that efficient, directing only 39 percent of the original source light in the desired direction. A much better system is that known as a dioptric light, which uses refracting lenses numbered from the first order downwards.

The dioptric system invented by Augustin Jean Fresnel used beveled-glass prisms that refracted and focused the light rays from the lamp into a horizontal beam, thus greatly magnifying the light's intensity. Fresnel's barrel-shaped array of lenses encircled the light source, collected and magnified it, then concentrated it in one powerful beam. Up to 80 percent of the light could be captured and transmitted to sea for up to 25 miles (40 km). First-order lenses were considered coastal, while beacons such as the one at Île-Bicquette were less powerful and therefore rated as second-, third-, or fourth-order lenses, to be used in harbors and channels. GF

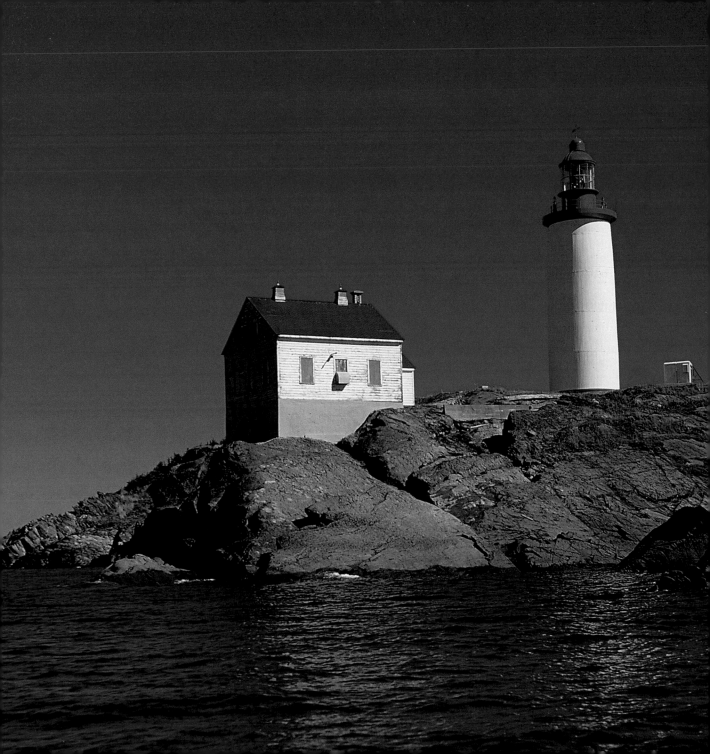

Pointe-au-Père

A t a little past 2:00 P.M. on a foggy Friday, May 29, 1914, only five years after the Pointe-au-Père lighthouse was built, it received an S.O.S. telegraph from Captain Henry Kendall from the passenger ship *Empress of Ireland*: "We have been struck by the *Storstad* on our starboard side just aft of the watertight bulkhead. Water is pouring in. Have stopped engines. No lights or power. Attempting to beach the vessel. Send assistance." The lighthouse staff contacted rescuers in nearby Pointe-au-Père and surrounding area to help evacuate the sinking ship. In less than 14 minutes, after listing heavily to its starboard side, the ship sank in 150 feet (46 m) of water. The tragedy came to be known as "Black Friday," the worst maritime disaster in Canadian history, with 1,012 lives lost.

The irony of the tragedy was that officers aboard the two ships had seen each other several miles in advance, they had blown their horns to indicate that they were aware of each other's presence on several occasions but had failed to realize in the thick fog that they were on a direct collision course with each other. Suddenly, the *Storstad* emerged from the fog, the bow barreling down on the midsection of the *Empress*, no maneuvering or evasive actions by the two ships could alter their catastrophic destiny. Of the 1,477 passengers, only 465 survived the freezing waters. Rescuers found only lifeless frozen corpses bobbing in the river.

On May 12, 1999, almost on the 75th anniversary of the tragic sinking, the Canadian Coast Guard put up a marker buoy indicating the location of the sunken ship and notifying would-be treasure hunters that a government permit is required to visit the ship or take any items from it. It has been declared an underwater heritage site, and in 1998 was the subject of the documentary film *Sinking into Oblivion*.

I discovered that there are 128 grueling steps to the top of Pointe-au-Père lantern house, the second highest lighthouse in Canada. The original lighthouse was built in 1859 to guide ships through the dangerous currents, sandbars and shoals of Pointe-au-Père, where the St. Lawrence River meets the Gulf of St. Lawrence. Pilots familiar with the river were picked up here to help less familiar captains navigate inbound. The light was destroyed by fire twice before the current tower was built in 1909. Colonel Anderson's lighthouse was unlikely to be destroyed by fire, as it was built with reinforced concrete to a height of 97 feet (29.5 m). It is considered a flying buttress design because of the way the concrete pillars or buttresses fly off from the center lantern. The lighthouse keeper's house has been converted into a museum, with displays of nautical aids, photographs and items recovered from the *Empress of Ireland*. GF

Pointe-de-Mitis

D uring the early years of Confederation, the Government of Canada developed a policy on national transportation to improve internal communications and encourage colonization and commerce throughout the country. In 1870 the Department of Marine and Fisheries took control of Trinity House and initiated — under pressure by ship owners — an important lighthouse construction program, starting with those at Cap-de-la-Madeleine in 1871 and Pointe-de-Mitis in 1873–1874.

The new wooden lighthouses operated on inexpensive single catoptric systems, but as traffic on the St. Lawrence boomed due to soaring wheat exports to Europe and goods carried to port by two transcontinental railways, these lights were replaced with more powerful systems that could provide increased light, of better quality and greater magnitude, for faster ships. The new dioptric apparatus could not be supported by the old wooden structures. These had to be replaced by more solid and durable towers made of reinforced concrete. Construction of the new lights of Pointe-de-Mitis and Cap-de-la-Madeleine began in 1906.

The 82-foot (25 m) cylindrical cement tower at Pointe-de-Mitis was built on a long headland surrounded by wave-swept rocks that sloped into reefs. In 1923-1924, it had to be further reinforced, giving it its hexagonal shape. Each angle is supported by a 13-foot (4 m) arch. A small passageway joins the keeper's house, built in 1912, to the light. A second house was built in 1957. Today, the lighthouse and the buildings belong to the Department of Natural Resources of Canada and are protected by a fence. A tenant guided me through the sites.

To reach the lighthouse, you take Route 132 and cut off at Chemin du Phare (Lighthouse Road) between Grand-Métis and Métis-sur-Mer. Along the way, you will discover English villas dating from the late 1800s and surrounded by stone walls covered with moss and lichen. John Mac Nider owned the lighthouse site, built his first house here, then bought the Seigneurie Métis, a property on which he established many families who came over from Scotland. The Anglo-Saxon community grew and, at the turn of the century, "Métis Beach" became a fashionable summer resort with tennis courts, golf courses, summer homes, first-class hotels and salmon fishing for a posh clientele who longed for fresh air. CB

Matane

A rriving in Matane, you see a white tower topped by a red dome between two traffic lights: the lighthouse is right beside the tourist information center. The city grew up around the lighthouse. *Bienvenue à Matane.* The first lighthouse was built in 1873 on a cliff a mile (1.6 km) west of the Matane River. It was an era of wooden lighthouses. They were cheaper to build, in accordance with the means of a new nation. The 28-foot (8.5 m) tower measured 18 by 18 feet (5.5 x 5.5 m) at its base and narrowed to 12 by 12 feet (3.6 x 3.6 m) at its top. A tiny keeper's house was added. The catoptric lantern, 65 feet (20 m) above sea level, had a range of 10 miles (16 km).

The telegraph was installed in 1879, followed by a semaphore. From 1881 to 1904 the lighthouse had a distinctive black cross painted on its white wall facing the sea. The tower had to be moved 100 feet (30 m) inland in 1894 due to erosion of the cliff.

In 1906–1907 steel panels were assembled and covered with concrete — painted red — to form a new cylindrical tower of 67 feet (20 m), carrying a dioptric light visible 15 miles (24 km) away. In 1910 a new house was built for the keeper, and the old lighthouse was dismantled.

For the six keepers who worked successively in the two lighthouses, daily chores included maintaining the flame from dawn till dusk, caring for the proper functioning of the lamps and cleaning the reflectors. They also had to keep the dwellings and outbuildings clean and in good repair. They kept a daily log of major events, a register of oil consumption, and twice a year ordered their provisions.

Camille McKinnon was the last keeper, from 1935 to 1951. He was there when a German ship was boarded and inspected in 1939, just days before the Second World War was declared. In December 1946 he helped rescue a Québec Airways plane after it crashed onto the river's ice packs northwest of Les Méchins.

In 1951 the Historical Society of Matane bought the lighthouse for one dollar. It is now an exhibit center and tourist information center, with the City of Matane responsible for its preservation. CB

Pointe-des-Monts

Traveling east on Route 138, on the north shore between Godbout and Rivière-Pentecôte, you will see a sign indicating the Pointe-des-Monts lighthouse. Follow the winding road between slopes of stunted vegetation where wild blueberries are plentiful and blackflies numerous. As you approach the coast, you will see some buildings and a small white-and-red Native chapel, built in 1898. At the tip of the headland, the white-and-red Pointe-des-Monts lighthouse stands seven stories high on the rocks. A lovely white-and-red footbridge provides access to the lighthouse when the tide is high. The old keeper's house, a few outbuildings and an explosives magazine with two cannons also occupy the tiny island. From 1868 to the end of the nineteenth century, these cannons were used as sound signals for ships in distress. They were later replaced by dynamite cartridges and eventually by a compressed-air whistle.

In 1826 Trinity House chose the area where the estuary widens into a gulf as the future site of the new lighthouse, which was built in 1829 and 1830. This location allowed the new light to guide gulf-bound ships away from Anticosti Island and showed those sailing upstream the way to Bic Island.

The wall of the tower supporting the lantern is 6 feet thick (1.8 m) at the base and 2 feet (.6 m) at the top. The lighthouse is operated with a catoptric system using 13 bronze Argaud burners with copper pipes and as many parabolic reflectors.

This 90-foot (27 m) monument housed eight keepers. Between 1872 and 1954, three generations of the Fafard family worked in the lighthouse. The many children helped their fathers fish, tie nets, and on long winter evenings listen to tales of men carrying the mail over ice floes and through forests on dog sleds.

The lighthouse was closed in 1964. The last keeper to work there, Jacques Landry, was among those who worked to preserve it. The lighthouse now hosts a very nice exhibit on the life of the keepers and their families. The main house offers delightful meals. Jean-Louis Frenette served us an appetizer of seal, followed by an entrée of salmon and halibut, accompanied by a good wine. He then walked us to our rooms. Fire no longer burns under the dome of the Pointe-des-Monts lighthouse, but there is a true warmth just the same. CB

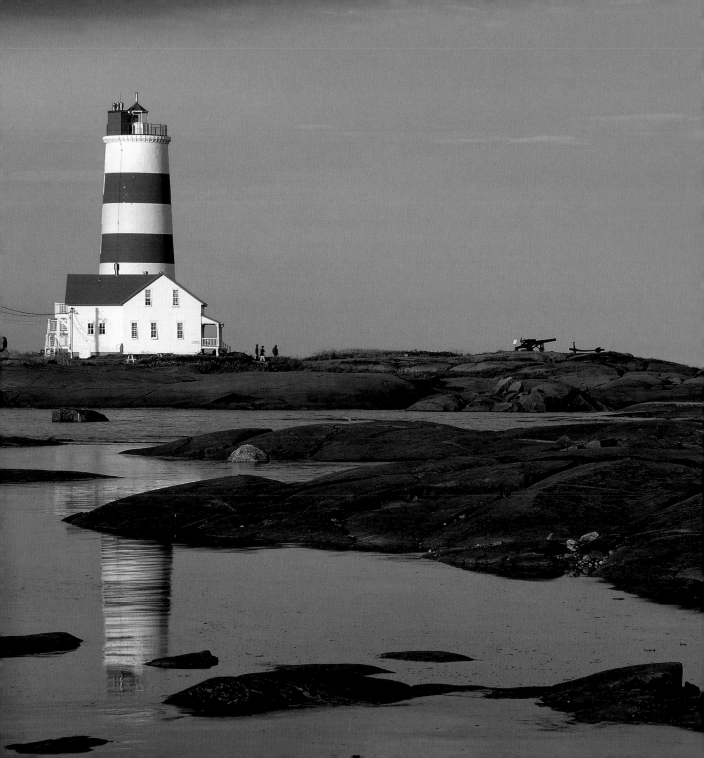

Cap-Chat

C ap-Chat is located where the Gulf of St. Lawrence narrows and becomes an estuary. The coast of Gaspésie may seem straight, but in fact its curves require constant adjustments due to the strong currents and many reefs. Ships heading south often ran aground in the area when they traveled in the fog or at night.

The region was the scene of hundreds of shipwrecks. It has been suggested that a privately owned lighthouse was in operation around 1811, but it was in 1870 that a lighthouse at Cap-Chat was made a priority by the government. Lord Dufferin, Governor General at the time, announced that it would be the most important lighthouse at the entrance of the river.

The first official lighthouse was built the following year. It was a small wooden tower erected on a 100-foot (30.5 m) cliff. The frame was strong enough to support a strong, high-quality lantern. With the lighthouse came the development of a local fishery and the timber trade, and with that, the growth of the community of Cap-Chat.

In 1884 the lighthouse had to be moved due to erosion of the cliff, and improvements were made in 1900. In 1909 a concrete tower was built. The new, relative short, 33-foot (10 m) lighthouse was located to take advantage of the height of land. The lighthouse was covered in cedar shingles. Its lighting system was visible 25 miles (40 km) out to the sea.

It is now a café and restaurant, and also houses a winds and oceans interpretation center. Before you reach the lighthouse, you will see a museum on marine life, featuring the lighthouse and the wind turbines of Cap-Chat. A path leads through flowerbeds to the rocky cliffs where the lighthouse overlooks the reefs below the cape.

Between the museum and the lighthouse stands a huge monolith in the shape of a sitting cat, the inspiration for the name of the village and the cape. Close by, an explosives magazine, with its red roof and whitewashed walls, reminds visitors that explosives were once used on foggy days to warn mariners of the presence of the cliff and its dangers. CB

Île-du-Corrosol

I was introduced to the island of Corossol in 1972, along with ten fellow students, when, under the supervision of our Natural Science teacher, Bertand Blanchet, we did a flora and fauna range survey of the entire island — all half square mile (1 km^2) of it. We discovered many bird species nesting on its cliffs: black-legged kittiwakes, razorbills, black guillemots, guillemot marmettes. The island was also filled with terns, herring gulls, great black-backed gulls and double-crested cormorants. Schools of mackerel swam the waters surrounding the island. While fishing, a friend of mine thought his canoe had sprung a leak when he heard a fin whale blowing alongside his craft.

During that week we were in touch with nature, but also with its local guardian, Marcel Galienne. He had been appointed lightkeeper in 1953 and was happy to show us around the lighthouse, the dwellings and the winch. During our stay, he offered us the use of his absent assistant's house and the basement of his own home. Galienne was the last keeper to work on Corossol Island. His reign lasted 32 years.

The island is named after the French vessel *Corossol,* wrecked here in 1693. It is the most southern of the six islands and group of islets in the bay of Sept-Îles. The lighthouse was erected for the surveillance of maritime traffic in the channel and to help boats navigate the reefs and islands.

The first lighthouse, built in 1874, burned down the same year. It was replaced the following year. In 1956 a third lighthouse was built. The octagonal concrete tower has a diameter of 19 feet (6 m) at its base and 9 feet (3 m) under its dome. It measures 56 feet (17 m) high and could, in its prime, send a beam 190 feet (58 m) over high tides. It witnessed the growth of the harbor of Sept-Îles but was abandoned in 1988.

The island of Corossol is now a bird sanctuary accessible during summer with a permit from Environment Canada. You can, however, board one of Gaétan Bouchard's taxi-boats at the Sept-Îles marina and visit some of the islands run by the Tourist Corporation of Sept-Îles, or simply circle Corossol Island. The morning I visited Corossol for this photograph, I saw white-sided dolphins breaching the waters of the bay, and a blue whale passing the island below its lonely, weather-worn lighthouse. CB

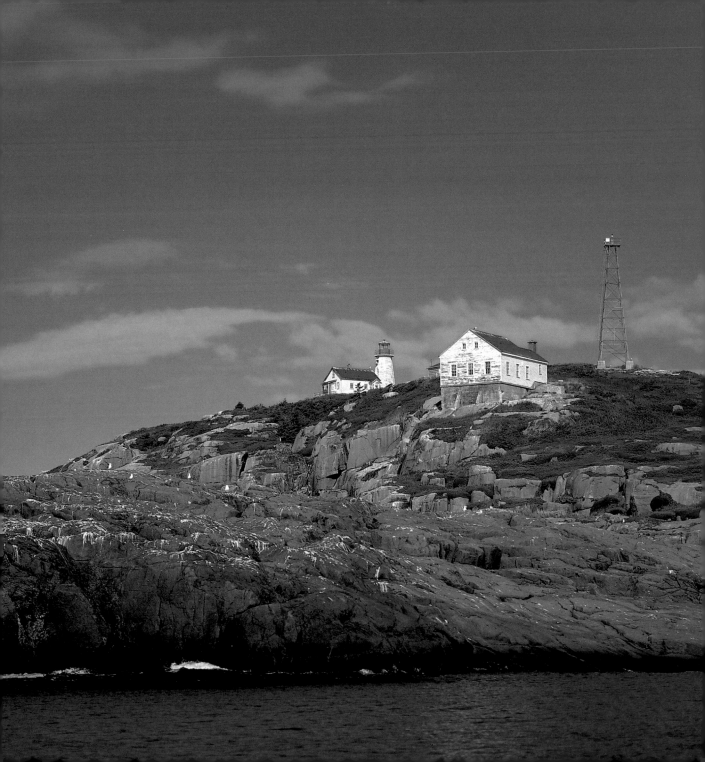

La Martre

I n the small coastal village of La Martre, a lighthouse proudly overlooks the Gulf of St. Lawrence and the steep coast of Gaspésie. The first lighthouse was built here in 1876 to fill a navigational gap between the lights at Cap-Chat and Cap-de-la-Madeleine. It was built within the house of its first keeper, Jean-Baptiste Gauthier, a tall, stern but cheerful man. The Gauthiers had eight children, two of whom went on to work in the lighthouse. Jean-Baptiste retired in 1902, at the age of 61, and the following year received the Imperial Service Order medal in honor of his 26 years.

Auguste Leclerc, a 52-year-old merchant, succeeded Gauthier. A new octagonal wooden lighthouse was built in 1906. The structure supported an English-made circular lantern floating on a bed of mercury. Its powerful beam could reach 130 feet (40 m) above high tides. The lighthouse was red and bore a large vertical white stripe facing the sea. Leclerc lost his job in 1912, following the election of Louis-Philippe Gauthier (Jean-Baptiste's son) as Member of Parliament for Gaspé.

Enter the third keeper, Joseph L'Italien, husband to Éliane — Louis-Philippe Gauthier's sister. Joseph and Éliane's 12 children were often jeered at because of their father's political allegiance. Joseph was 33 years old when he started his 34-year lightkeeping career. His son Raymond assisted him from 1929 to 1946, replacing him for a year at the end of his term, and Éliane took charge of the telegraph.

During this period, the Liberal MP promised Cap-de-la-Madeleine lightkeeper Jean-Baptiste Caron that he would remove the L'Italiens from their post. In 1947 Jean-Baptiste's son, Paul Roger Caron, a young soldier returning from the war, was appointed keeper of the La Martre light. While fighting in Europe, young Caron had learned telegraphy, radio, Morse code and mathematics. He was known to be a generous man, sociable, honest and a very good sailor. In 1955 he was appointed head of the keepers' association. In 1972 his station was automated, and Caron was transferred to the light at Cap-des-Rosiers, where he worked for another eight years.

The lighthouses of La Martre have been the scene of several shipwrecks. The *Feedjoff,* a Norwegian three-master went down in 1890, and one of her anchors remains on the site.

There are many stories to be told on La Martre by Yves Foucrault, a keeper who got his job because of his passion rather than his political connections. Foucrault is responsible for the social and cultural committee on lighthouses. Exhibits in the local museum illustrate the architecture, lighting and signaling systems of lighthouses dating back over 2,000 years to ancient Alexandria. CB

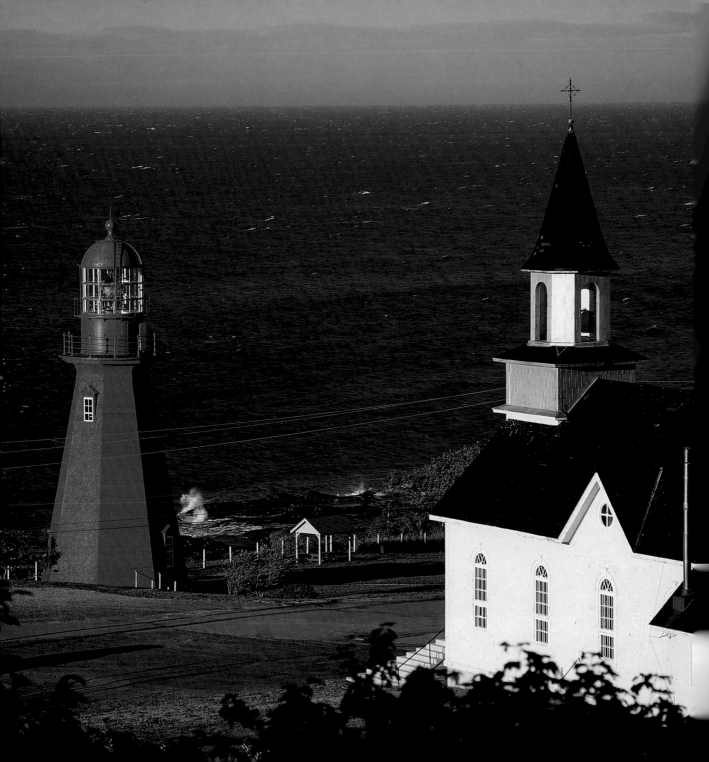

Cap-de-la-Madeleine

On the north shore of the Gaspé peninsula, between the small villages of Madeleine Centre and Rivière-Madeleine, stands the Cap-de-la-Madeleine lighthouse. Long before lighthouses were erected, captains used the cape to establish their position on the St. Lawrence. On May 4, 1868, a committee of the Department of Marine and Fisheries proposed construction of a lighthouse on this cape, as well as ones on the Rocher-aux-Oiseaux, the Escarpement Bagot, the Corps Mort, at Cap-Chat, and on Corossol Island. The Cap-de-la-Madeleine lighthouse was to begin duty in 1870, but the boat carrying its construction materials was caught in a storm and lost most of its shipment. The light and the keeper's house were finished a year later than planned.

In 1872 or 1873 the light was intensified. To further improve visibility, a black vertical stripe was painted on the white wooden structure in 1881. A steam whistle was installed in 1892, but this was replaced by a diaphone in 1904. The diaphone's system of compressed air ended each call on a sombre note. The semaphore, a mast with a combination of different flags enabling communication with vessels passing in the open sea, was installed in 1879, at the same time as the telegraph. At the beginning of the twentieth century, wireless telegraphy brought the end of the semaphore.

A new tower of reinforced concrete was built in 1907, close to the old light, which had to be demolished. The new tower measured 55 feet (17 m) high and 11 feet (3.5 m) in diameter. The tower is accessed through a small porch and is topped by a red dome containing the catoptric lantern — five times stronger than the previous one — and a weather vane.

In 1956 a new two-story house was built for the keeper and a smaller one for his assistant. The old house, in which both keeper and assistant had lived together, was dismantled. The site has not changed much since. The keepers left the lighthouse when it was automated. Since 1973 it has sent its signature signal of three flashes of two seconds interrupted by two eclipses of three seconds and a final one of 18 seconds.

The first lighthouse watched on as permanent houses were built for the region's fishermen. From its rocky headland, the beacon guided steamships passing in the open sea, as well as fishermen and captains of schooners wishing to drop anchor in the mouth of the salmon-rich Madeleine River, just below.

The second light was also a boost for local economy. The Madeleine River would become one of the most important fishing harbors on the coast of Gaspésie. Locals often took the little winding road leading to the lighthouse in order to use the only available telegraph in the area. Nowadays, the road is paved and leads the way for tourists and anglers. The buildings house a tourist center that offers tours of the region. CB

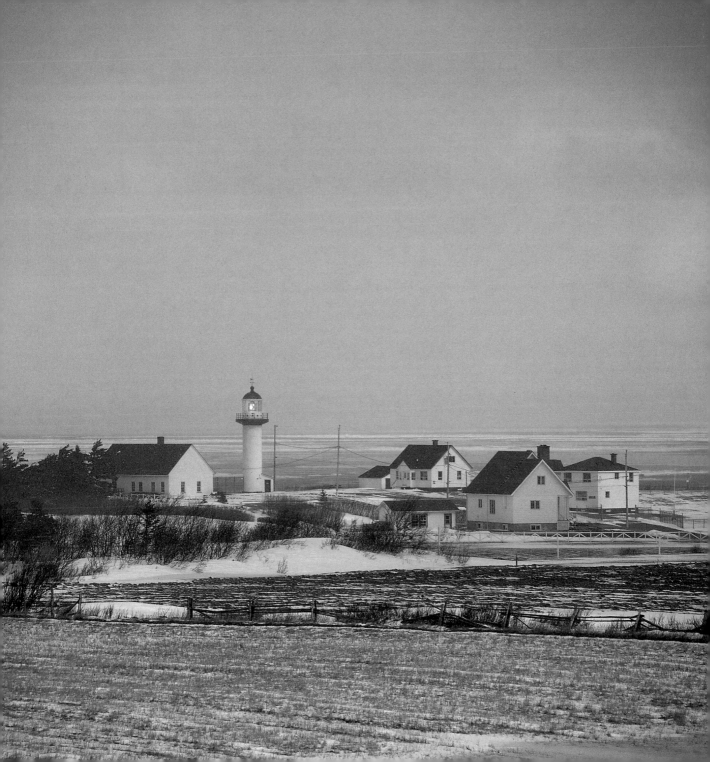

Pointe-à-la-Renommée

In 1870 it was decided that landmarks would be installed between Matane and Cap-des-Rosiers. The Pointe-à-la-Renommée lighthouse was built ten years later. Two events may account for the light's name. The first is the wreck of the *Renommée*, owned by a man from La Rochelle, off Anticosti, in 1736. Of the 54 crew and passengers aboard, only a handful were able to reach the island. Half then went in search of help and the other stayed on, with neither fire nor food. Their rescuers found them in an advanced state of exhaustion. The second possibility also has to do with a shipwreck in which many of the survivors died of starvation. This piece of land was once called Pointe-à-la-Faim (Point Hunger), perhaps wrongly translated into English as "Fame" and back into French as "Renommée." In both cases it was a question of hunger, *faim*, but the name Renommée was nevertheless appropriate.

The first lighthouse was constructed entirely of wood, for economic reasons, and painted white. (The "economy" of building with wood meant frequent high repair costs.) The 50-foot (15 m) tower was built within the keeper's house. The light shone 200 feet (61 m) above high tides and had a range of 20 miles (32 km). A small fishing community was established close to the lighthouse and witnessed the installation of the first maritime radio station in North America — by Guglielmo Marconi himself.

In 1906 a second tower was built of cast-iron panels supporting a new, first-class dioptric apparatus with the power of 500,000 candles. This new light began operation on October 1, 1907, and was visible 50 miles (80 km) away, as far as Anticosti Island.

In 1909 Pointe-à-la-Renommée made news as the result of a revolt by local fishermen against the questionable practices of the trading companies concerning cod. In 1942 it witnessed the rescue of the *Nicoya* after she was torpedoed by a German submarine. The victims were taken in by residents of Cloridorme and L'Anse-à-Valleau.

The Pointe-à-la-Renommée lighthouse was closed in 1975, and its duties replaced by a tower in L'Anse-à-Valleau. The dismantled light was moved to Québec City's old harbor, where it remained as a tourist attraction for 20 years. But the people of L'Anse-à-Valleau and their the local development committee were determined to get their lighthouse back. They proved successful and are now working toward reconstruction of the surrounding buildings. CB

Cap-des-Rosiers

S amuel de Champlain, it seems, named Cap-des-Rosiers in 1632 after the abundance of wild roses in the area. For centuries they have withstood the elements and have witnessed the great storms that have come in from the east to cause — here, more than anywhere else in Gaspésie — the loss of ships in the deadly surf of the cape and its surrounding rocks. Cap-des-Rosiers was considered strategic, as it was a ship's first sign of the continent after crossing the Atlantic. From May 1840 to September 1848, there were eight wrecks in the vicinity of Cap-des-Rosiers, most of them with great loss in human lives and material. In May 1847, 140 Irish perished from the wreck of the *Carick*.

The contract for construction of a lighthouse at Cap-des-Rosiers was granted in 1853. The stonework wall was built of thick, flat stones and measured 25 feet (7.6 m) in diameter at its base. The tower measured 95 feet (29 m) in height and 17 feet (5 m) in diameter at the top. With the dome, its total height was 112 feet (34 m), making it the tallest lighthouse in Canada. The exterior wall was covered with English-made fire bricks, on which three layers of thick, leaded paint were applied. The interior was coated with two layers of plaster. A first-class French dioptric apparatus was installed under the dome. The best technology available. The Saint-Gobain glass, transparent and very hard, had a high silica and lime content in for protection against the elements. Standing 135 feet (41 m) over high tides, the lens sent a beam 16 miles (26 km). It was lighted for the first time on March 15, 1858. The St. Lawrence now had its sentinel.

In 1869 whale and porpoise oil were replaced by refined white petroleum oil – five times cheaper – which was cleaner and gave a brighter flame. In 1903 the fixed white light was transformed into an occultation light. The eclipse system permitted to tell the lighthouse apart from the lights of buildings and stars. Around 1921–1922 the power of the burner was increased. Finally, in 1950, the lighthouse was electrified.

In 1956 the 100-year-old residence was demolished. A new house and outbuildings for the foghorn and radio beacon were built. The outbuildings burned down the following year but were immediately replaced. In 1970 the 1,000-watt electric bulb was replaced by a 400-watt mercury-vapor lamp, more powerful and with a longer life span.

The lighthouse was designated a historical monument in 1977. Though automated in 1988, it continues to send its beam over the Atlantic like a beacon of hope from a new land. CB

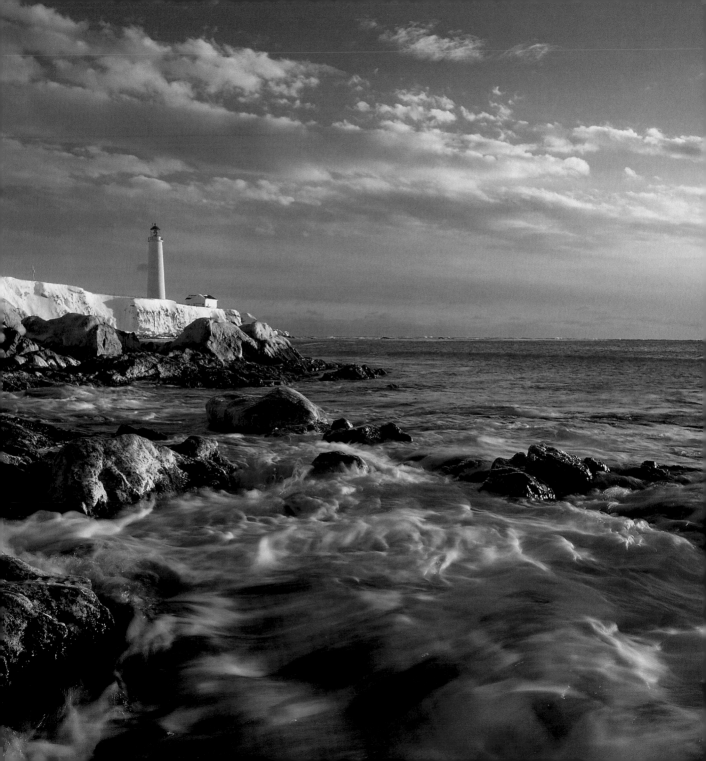

Cap-Gaspé

O n this last Sunday morning of September, rain and fog shrouded the small village of Cap-aux-Os. The previous day, I hadn't been able to take pictures of Cap-Gaspé due to clouds, but as I crossed the bridge leading to Gaspé, I looked in my rear-view mirror, hoping for a bright interval, and there it was! A half-hour later, I parked my truck at L'Anse-aux-Sauvages, south of Forillon Park, and started the 3-mile (5 km) hike to lighthouse.

On the right side of the path in the last curve leading to the cape, there is a derrick that overlooks the cliff. The light was built in 1873, and during the early years the derrick was used to unload the *Napoleon* III and the *Newfield*, two steamers that supplied the station.

On top of the cape, close to the edge, a small building known as "Cape Gaspé Station" harbored the fog cannon from 1883 to 1894. Until 1950 guncotton cartridges were shot from the station's roof to warn fishermen and mariners of the dangers lurking off the cape. Above the station, a shelter for the steam whistle is now used by hikers. Built in 1950 of cement coated with white roughcast, the new light is supplied by solar panels.

Previous wooden lighthouses were built next to the keeper's house on the 298-foot (91 m) cliff at the tip of the Forillon peninsula, facing the Atlantic. The first one, destroyed by fire in 1890, had a fixed red light operated by a catoptric system with a 12-mile (19 km) range The second lighthouse had a stronger beam. It was operated by another catoptric system but with a white light visible from a distance of 26 miles (42 km). In fog, it indicated the three rocky islets emerging from the shoals below the cape where the peninsula extends under the Atlantic. During storms, it guided captains to the calmer waters of the Gaspé Bay.

In 1950 a diaphone replaced the cartridges that were sent cracking over the fog banks. In 1961 two new houses were built, one for the keeper and one for his assistant. The years 1971 and 1972 witnessed the automation of the lighthouse, the departure of the keepers and the removal of the dwellings from Forillon Park.

Nowadays, the Cap-Gaspé lighthouse is a tourist attraction within Forillon Park. The path leading to the cape from L'Anse-aux-Sauvages crosses the south section of the peninsula. You may come across porcupines or foxes, or even see black bear tracks as you walk along the rugged cliffs and through the fields of fireweed above the ocean.

Late in September, many tourists still walk along the cliffs of the cape to watch the seals basking on the rocks. On this day, I chose to remain at the lighthouse with a couple from Corsica and three French photographers. The sun caressed the top of Cap Bon-Ami and the deep blue waters of the gulf. At a perfect moment, a whale breached — three times — each time crashing with all its might and spraying waves high into the wind. Back at the hostel, and later at the restaurant, Chez Mona, the six of us, like children in awe, couldn't stop talking about what we had seen that afternoon. CB

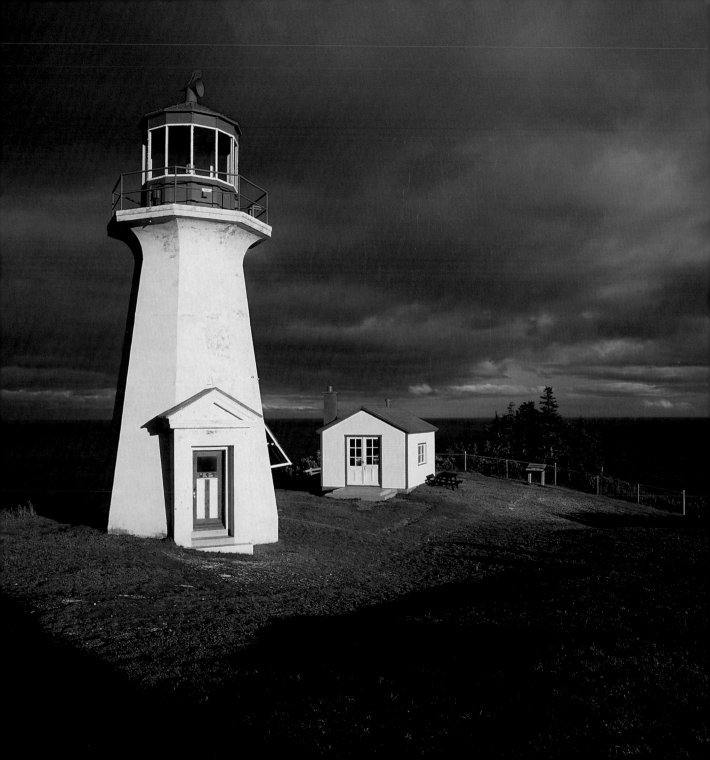

Cap-d'Espoir

Even though I had traveled the peninsula for seven years, three to five times a year, Cap-d'Espoir had escaped my lens. Leaving Percé on Route 132, beyond the village of L'Anse à Beaufils, you come to a stretch of headland jutting out into sea yet dotted with farms! Below, the lighthouse and its outbuildings appear in a harsh but charming maritime landscape that looks like a scene from another era, an enclave that has resisted time and commercial development.

It is here that the Gulf of St. Lawrence meets the Baie-des-Chaleurs, where, in the eighteenth and nineteenth centuries, the burgeoning cod fishing industry led to population of the coast of Gaspésie. In the absence of roads, the sea was the primary route for transporting goods. During the first years of the Canadian Confederation, a good part of trade traffic between Montréal and the Maritimes went through Baie-des-Chaleurs.

The decision to erect a lighthouse here was made in 1871. After collecting sufficient funds, a little wooden lighthouse and a keeper's house were built in 1873. Atop the 90-foot (27 m) cape, the white light swept the waters of the gulf and the bay, guided ships sailing to Chandler, Dalhousie and Campbellton, and aided transatlantic transport. Above all, the little white beacon was particularly valued by the fishermen from Gaspésie when violent storms hit the coast and dense fog settled in.

By 1939 the lighthouse had rotted beyond repair and had to be replaced by an octagonal tower made of cement, a construction material that met current fire safety measures and durability requirements. It was a classic shape: a sturdy base with a tapered column that widened at its top to support the red dome. With its 48-foot (14.6 m) tower, with three stories and a window on each story, it resembles the lighthouses of Cap-de-Bon-Désir, Cap-au-Saumon and Cap-Gaspé. Pediments over the openings of the first and second floors protect the structure against rain damage. The third floor and its walls are protected by the widened section of the tower. The structures of cement lighthouses are damaged mainly due to alternating periods of rain and rapid dryness. For this reason, a special water-repellent paint is applied regularly.

In 1959 the old keeper's house was demolished, making room for two new residences, one for the keeper and the other for his assistant. The station was automated in 1987, and the lighthouse received a national heritage designation in 1989.

The lighthouse is still in operation and belongs to the Canadian Coast Guard, along with the old foghorn, a shed and two garages. The houses were sold. Their owner, Raymond Lalonde, is also president of the association for the preservation of the lighthouse and with wife Isabelle Anna Maria runs an inn in the old assistant's house. The site, on the cliff, is an exceptional place for bird- and whale-watching. Cap-d'Espoir (Cape Hope) is a perfect name. CB

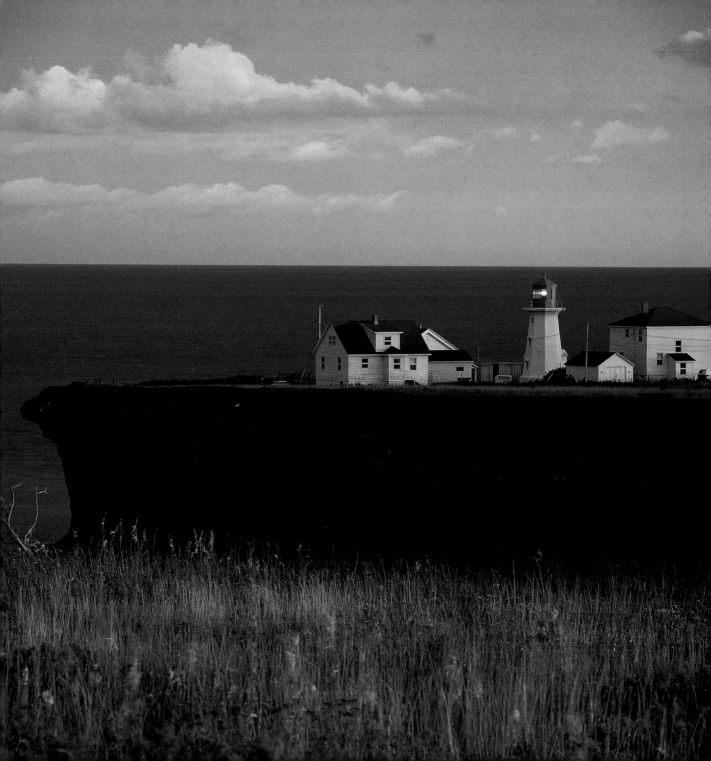

Bonaventure

Bonaventure is in the heart of Québec's Acadia. In 1902 a small square wooden lighthouse was erected on Pointe Échouerie. The white tower supported a red octagonal lantern. Its fixed white light was operated by a seventh-order dioptric system with a range of 12 miles (19 km). It signaled the presence of the coast to mariners traveling this part of Baie-des-Chaleurs. From its base to its dome's ventilator, the lighthouse reached 34 feet (10 m) in height. The first keeper, Louis Bourdages, earned a salary of 60 dollars per year.

In 1906 a lighthouse inspector named Captain O'Farelle insisted that the lighthouse was not on a suitable site because captains could not see it properly when approaching from the east in Baie-des-Chaleurs. In the spring of 1907, it was moved to Pointe Bonaventure, a mile and a half (2.4 km) down the coast. In 1912 the fixed light was replaced by a fifth-order occultation light with a signal of 15 seconds followed by an eclipse of five seconds.

In the early 1950s a foghorn was requested, but it was decided that Cap-de-Bon-Désir should have it, since traffic was greater in that area and because that part of the north shore was much foggier: "The weather is nice in Bonaventure."

Théodore Babin, the last keeper, began his term in 1958. He worked there till the day the old petroleum-vapor burner was turned off and the lighthouse was electrified, on October 31, 1965.

In 1976 the cedar shingles were covered with white metal siding. In the autumn of 2000, as I was taking the short path leading to the lighthouse from Route 132, a fresh coat of paint was being applied. A farmer was spreading manure in his field. He smiled to me. I met a young boy who lived in a neighboring house. He had just returned from the cliff, where he filled pails with sand, which he used to build the little houses that he sold to tourists. He offered to show me his collection, but sadly I had to refuse his invitation. The glow of the sunset was bathing the cliff, the dried grass and the lighthouse in the kind of light a photographer cannot resist. CB

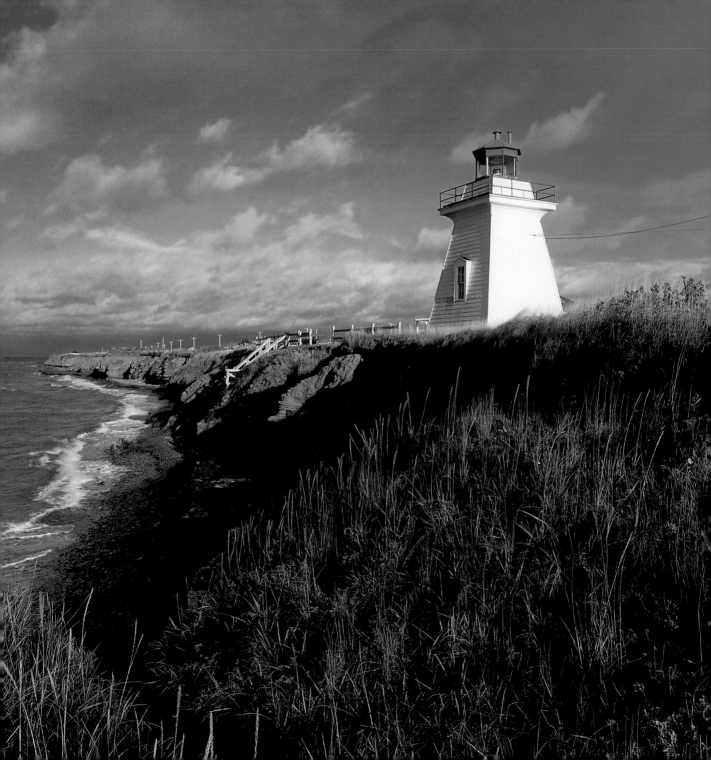

Carleton

In Carleton, a long lagoon projects into the sea, forming the tip of Tragadigache, at the end of which stands a simple white wooden lighthouse topped with a red dome. It dominates the arrow of sand, the lagoon's herbaceous vegetation and Baie-des-Chaleurs. I long had the impression that the lighthouse was here just for appearances — appealing only to tourists — but I was wrong. The lighthouse is an intrinsic part of the landscape, like the blue herons in the lagoon.

The first wooden lighthouse, erected in 1872, was also the keeper's dwelling. It guided the fishermen along the coast and the ships heading for the far end of Baie-des-Chaleurs. Its light, red at first then white, had a range of 12 miles (19 km). A red shed was used to store oil for the lamps and wood for the keeper. Over the seasons, the weathered lighthouse required many repairs. The foghorn was installed in 1900.

In 1905 another lighthouse was built, on the wharf in Carleton. The lighthouse at Tragadigache was demolished in 1911 to make way for a new wooden one, with slanted walls sitting on a cement foundation. It was topped with a red octagonal dome and measured 32 feet (10 m) in all. It had no dwelling for the keeper, but had a heated shelter in which he could take refuge on stormy nights. Two windows opened, southward and eastward, onto Baie-des-Chaleurs.

The tower's fixed white light was changed for a flashing light in 1913 and remained as such for the next 40 years. In 1953 it became green, and then red in 1956. Its special code and color told it apart from its "workmate" on the wharf, whose red light remained fixed.

The lighthouse on the wharf was removed in 1957 and replaced by a skeleton structure. By 1967 the foghorn was no longer in use. The old lighthouse on Tragadigache was burned in 1970, and a skeleton structure replaced it, too.

But the story does not end there. Tragadigache's spirit was missing. In 1984 a replica of the former lighthouse was built. On stormy nights, one always needs a guiding light. CB

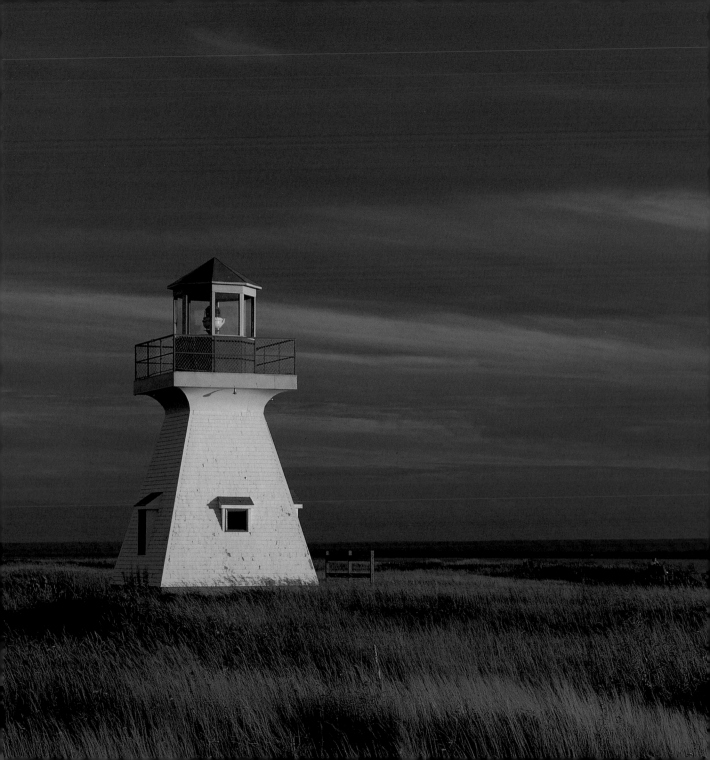

Île-aux-Perroquets

It was aboard Yves Chiasson's Zodiac, *Mer Cure*, that I came to Île-aux-Perroquets. With his wife, Carole Routhier, Yves operates a bed-and-breakfast called La Bécassine in Longue-Pointe-de-Mingan. They share a common passion for the islands of Mingan.

Before the lighthouse, shipwrecks were numerous around Île-aux-Perroquets, including the steamships *Clyde* (1857) and *North Britton* (1861). During a storm that lasted three days in October of 1876, the schooners *Catherina, Notre-Dame-de-Lourdes, Lady Elgin, Sainte-Croix* and *Zelia* went down with all hands. The island's original lighthouse was built in 1888.

The first lightkeeper was Count Henri de Puyjalon, born in 1840 in the castle of Ort, near Bordeaux, France. After spending time in Montréal's salons, he left to explore the north shore of the St. Lawrence River. He later traveled to Paris, where he stayed for two years before abandoning the fashionable life to return to the north shore. Here he met Angelina Ouimet, who followed him on his exploration trips and gave him two sons. Henri de Puyjalon dedicated himself to making an inventory of the north shore's natural resources and ensuring their protection.

In 1892 Eustache Forgues, the second keeper, drowned with his assistant while returning to the island during a storm. On January 6, 1954, lightkeeper Robert Kavanagh and his assistant were trapped in ice floes when their boat failed. They promised to erect a statue to the Virgin Mary if they were saved. The ice parted, opening a passage to the island. Kavanagh has fond memories of his time at the lighthouse: "L'Île-aux-Perroquets was a family haven where our five children lived happily and played freely."

In 1951 a 35-foot (11 m) tower of steel and concrete, covered in a white roughcast, replaced the original wooden lighthouse. Today, it still stands, with the puffins its sole companions. CB

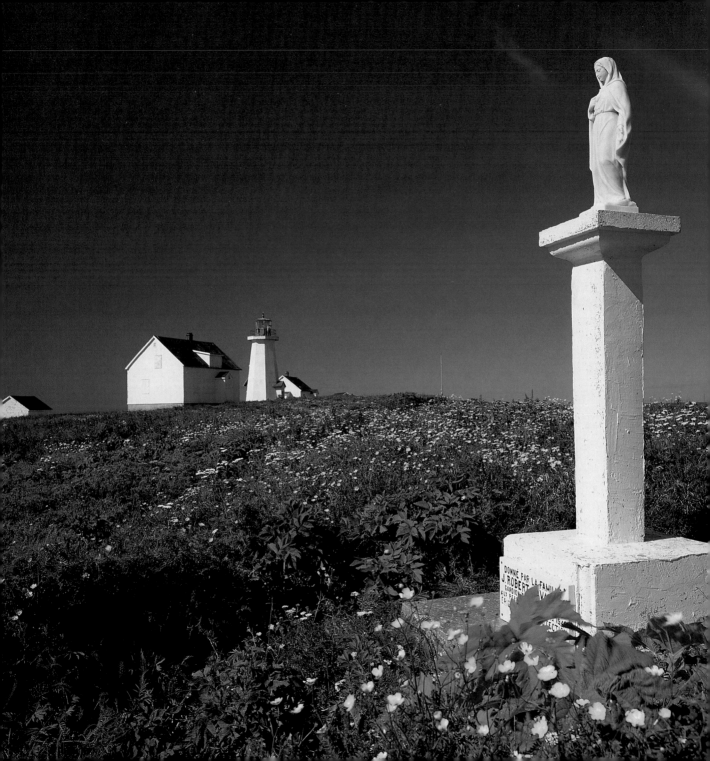

Pointe-Carleton

By 1885 a regular steamship service was supplying the north shore of the St. Lawrence. In 1919 the north shore of Anticosti Island was equipped with three new lighthouses — Cap-de-Rabast, Pointe-Carleton and Cap-de-la-Table — for the purpose of guiding the increased maritime transportation north of the island. This canal was not only shorter, but also less foggy than its southern counterpart.

To reach Cap-de-Rabast, you must drive 11 miles (18 km) on the Trans-Anticosti, then 27 miles (17 km) to the north. To reach Pointe-Carleton, on the other hand, you must drive 73 miles (118 km) on the main route — a timber road on which trucks raise clouds of dust fit for the *Guinness Book of Records*.

Moreover, the gravel is shards of limestone, meaning that if you brake hard, you are in for a flat tire, or two. Renée Martineau, my guide, kept telling me, "Not so fast, Claude, you'll have to brake less often. Not on the shoulder!" My visit was quite an ordeal for her. But I am proud to say we had only two punctures. Renée is a photographer and naturalist for Sépaq, a paragovernmental agency that runs recreational and tourist activities for most of the island. Pointe-Carleton is the *pied-à-terre* for the employees in charge of the restoration of the lighthouse site.

The octagonal lighthouse is made of cement covered in a white roughcast (a mixture of plaster and small stones) and topped by a red dome like the ones at Cap-de-Rabast and Cap-de-la-Table. It measures 40 feet (12.2 m) and produces a one-second flash followed by a five-second eclipse. During winter, keepers were isolated and the mail arrived by air. The pilots just threw the mailbag overboard when above the lighthouse.

On the morning I took this picture, a young woman was taming a few deer and a hare was grazing by the lighthouse and the keeper's old house. From the cliff, you can often observe a piked whale or a fin whale.

If the island of Anticosti has a reputation as a paradise for nature lovers, it also has the unenviable distinction of being thought of as the St. Lawrence's cemetery. This bad reputation may well be overrated. Nevertheless, between the shipwreck of the *Renommée* in 1736 and the *Calou* in 1983, there were 179 officially registered shipwrecks in these waters, including a few tragic ones. In 1954 the *M.V. Wilcox* ran aground at Rivière Patate, almost a mile (1.5 km) east of the lighthouse. No deaths were reported, but the old mine detector ship has become a local attraction. CB

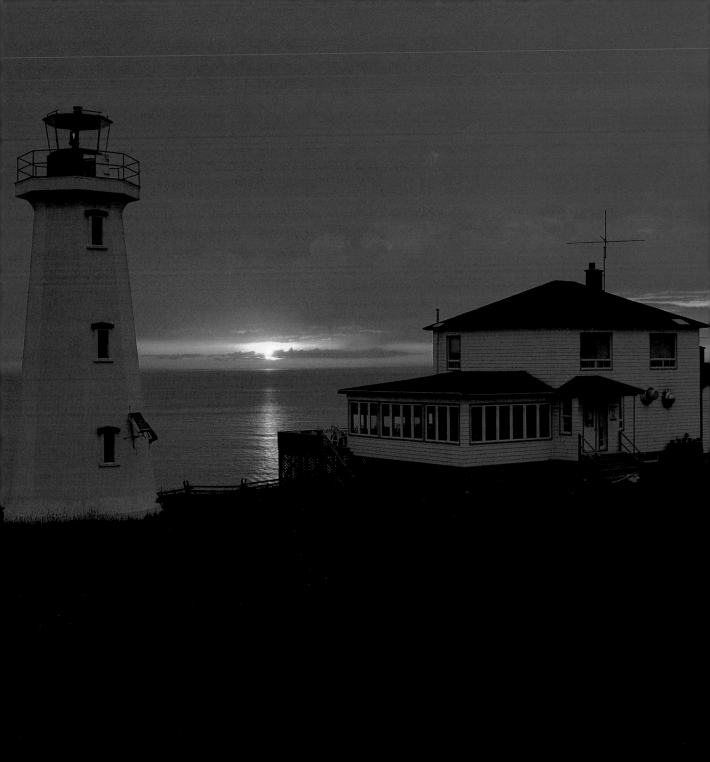

Cap-de-la-Table

After visiting Observation Canyon, Vauréal waterfalls, Jupiter River and the Pointe Sud-Ouest lighthouse on the island of Anticosti, I pondered whether the extra drive, 80 miles (130 km) between Pointe-Carleton and Cap-de-la-Table, would be worth it. It was.

At kilometre 186 on the Trans-Anticosti route, we cut off on the road leading to Rivière-aux-Saumons. This site, its river and the Cap-de-la-Table lighthouse are run by the Safari-Anticosti Outfitters. From the headland that overhangs the blue waters at the mouth of the river, we could see salmon jumping out of the water. Sculptures made of stone, wood, steel and wrought-iron line the bank because Safari-Anticosti offers accommodation to artists in exchange for a work of art done on location. The mouth of the Rivière-aux-Saumons and the site of Cap-de-la-Table have become a garden in which works of art blend into nature.

The 40-foot (12 m) lighthouse is a white octagonal tower topped by a red dome. It appeared before us in the light of the setting sun. We were welcomed into the keeper's house, now converted into a restaurant. Close to the lighthouse, Baie-du-Renard was the scene of many shipwrecks, including the sailboat *Granicus* (1828), the barge *Flora* (1832), the steamer *Vandalona* (1878); *Marguerite, MCK* and a third schooner (1884); the steamer *Brooklyn* (1885), the schooner *James and Ella* (1890), the steamer *Melbo* (1897) and the schooner *Mystery* (1911).

The story of the *Granicus* is particularly gruesome. In November 1828 the boat, loaded with wood, wrecked on the reefs close to the bay. On May 8 of the following year, Captain Basile Giasson discovered the bodies of 23 men, most of them dismembered and decapitated. There were clear signs of cannibalism, and they seemed recent. The last entry in the captain's logbook was dated April 28, 1829. In June, the bodies of two men were found under a big tree a few miles from where the drama had unfolded. Close to them, a beam was found bearing the carved words "What sadness. What pity." CB

Pointe-Sud-Ouest

H aving read about the lighthouse of Pointe-Sud-Ouest, I really wanted to discover the prairies said to surround the site, to visit the old cemeteries where old keepers and victims of shipwrecks had been buried. I wanted to touch the stones of the lighthouse.

At kilometre 74 on the Trans-Anticosti route, a junction offers a road to the south. Just in case the sign indicating Pointe Sud-Ouest is missing, it's best get some information beforehand and buy a map. You have 48 miles (77 km) to drive on a dirt road that eventually narrows, is less than well kept and has many cut-offs. The road comes out on the west side of the lighthouse and follows the shore, with its reefs and its bare, stunted trees. The lighthouse rises up out of the tall grass like a monument of a bygone era.

Construction of the lighthouse started in 1831 and took three years. The limestone was cut and extracted on the site. The tower was 80 feet (24 m) with a base of 36 feet (11 m). It stood 100 feet (30.5 m) above sea level, and its revolving light — the first in Canada — had a range of 15 miles (24 km). During its early years, the cold, damp stone tower was home to the keepers and their families, as there was no other residence.

Between 1828 and 1860, Anticosti was the scene of 47 shipwrecks. In 1836 four provision depots were installed along the south shore of the island, in the bay of Ellis, and on the southwest, south and east capes. Along the shore, little wooden signs were erected to indicate to shipwreck victims the direction and distance to the closest depot or other refuge. For a long while, a priest would come to Pointe-Sud-Ouest every spring for the burial of the bodies that had washed ashore during the winter.

The first lightkeeper was a Mr. Hammat. He was followed by Edward Pope in 1840. The Popes worked, from father to son, over the next 60 years. They cleared fields, grew gardens, raised livestock, fished and kept the light going and in good repair. The Popes' humble gravestones, surrounded by a battered wood fence, are reminders of their passing. Closer to the tower are the graves of John Edgar Joyce, from Newfoundland, and the crew members of the brig *Antine-Orient* who died on the reefs of Anticosti on November 22, 1871. Nearby lie the interred remains of 21 crew members of the British ship *George Channing*, wrecked in 1830 at Pointe-Sud-Ouest. No stone, no cross, no epitaph marks their graves — the simple piece of wood has rotted. As I was leaving, the sun was setting on the tower. I could not help thinking of all the lives, with their dramas, joys and miseries, that the stones had witnessed. CB

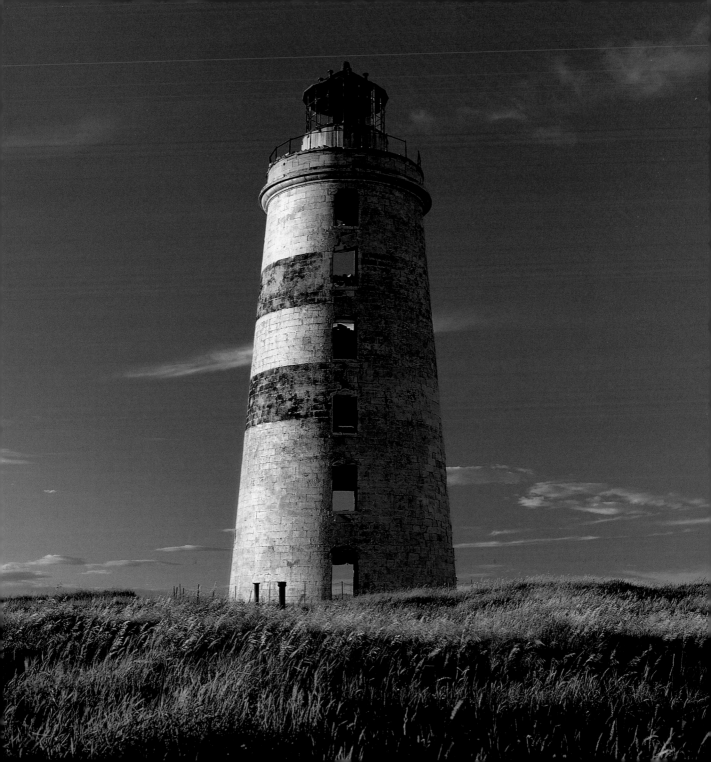

Île-d'Entrée

The lighthouse at the southwest tip of Île-d'Entrée is a welcome sight after the five-hour voyage from Souris, Prince Edward Island, aboard the passenger ferry *Madeliene*. This tiny island, 2 1/2 miles long (4 km) and a half a mile wide (.8 km), is the only island in the Magdalen Island archipelago that is not connected to the mainland. It is home to about 200 residents of Irish and Scottish ancestry.

You can reach the lighthouse from the main island of Cap-aux-Meules by catching the 8 A.M. ferry S.P. *Bonaventure* for the one-hour crossing to the port on Île-d'Entrée. From here it's about a half-hour walk to the light along unpaved Chemin Lighthouse (Lighthouse Street).

Originally built in 1874 to replace a fog siren, the octagonal tower reaches a height of 46 feet (14 m) and has a mercury-vapor electric light that can be seen 14 miles (22.5 km) to sea. The old foghorn has a second life as a lawn ornament in Isabell Mclean's backyard house, not far from the lighthouse. In summer she operates a bed-and-breakfast called Chez McClean. Isabell is an important source of information about the lighthouse. She will tell you that in 1908 it was destroyed by a thunderstorm and rebuilt two years later, and that before it was converted to electricity in 1962, it operated on a kerosene-vapor system. She is also very proud of the fact that former Prime Minister Pierre Trudeau visited the lighthouse in 1970.

This lighthouse had a habit of being moved, once in 1904, so that it could be on a hill close to the lightkeeper's home, and then again a few years later because the cape that it was situated on was eroding and the light was in danger of falling into the sea 95 feet (29 m) below. Nowadays, the lighthouse is surrounded by a fence and patroled by a couple of vicious dogs who don't like humans, so be careful!

The first known lightkeeper at Île-d'Entrée was Robert Cassidy (1887–1888). He was followed by James Cassidy (1888–1901). From 1905–1931, Leo, George and Wilfred Collins were the guardians of the light. John McLean was the last lightkeeper to maintain the lighthouse, from 1967–1988. In 1967 the fixed light became intermittent. In 1988 the lighthouse became fully automated. GF

Bassin

T he lighthouse at Bassin was built in 1871 and is considered by many to be the most beautiful in the Îles-de-la-Madeleine. Its unusual hexagonal shape was covered in cedar shingles. In all of Canada, there are only eight lighthouses of this particular style.

Like the keepers on Île-d'Entrée, Rocher-aux-Oiseaux and Île-Brion, the lightkeeper lived with his family in a house alongside the lighthouse. The first lightkeeper at Bassin was William Cormier (1871–1912). In the family tradition, William's son Charles took over responsibility of the light in 1912. The last lightkeeper was Edmond Boudreau, who maintained the light from 1950 to 1970, at which time the light was automated. The tower is 54 feet high (16.5 m) and situated on a cliff 98 feet (30 m) above the sea. A mercury-vapor lamp shines a distance of 16 miles (26 km) in good weather. Captain Remi Arseneau of the cargo ship *Voyageur* makes a weekly voyage from Montréal and knows that he has arrived back in the Magdalen Islands by the familiar pattern of lights that the Bassin lighthouse blinks in the early morning, a flash for two seconds followed by an eclipse of 12 seconds. Although Captain Arseneau now uses GPS and radar to guide the ship safely into port, he remembers the days when he relied solely on the lighthouses of the St. Lawrence River to guide his ship between Montréal and the Magdalens.

Visible from the lighthouse is the fishing port of Anse à la Cabane, one of the largest on the islands, where the king of the sea, lobster, is the main catch during the summer months. GF

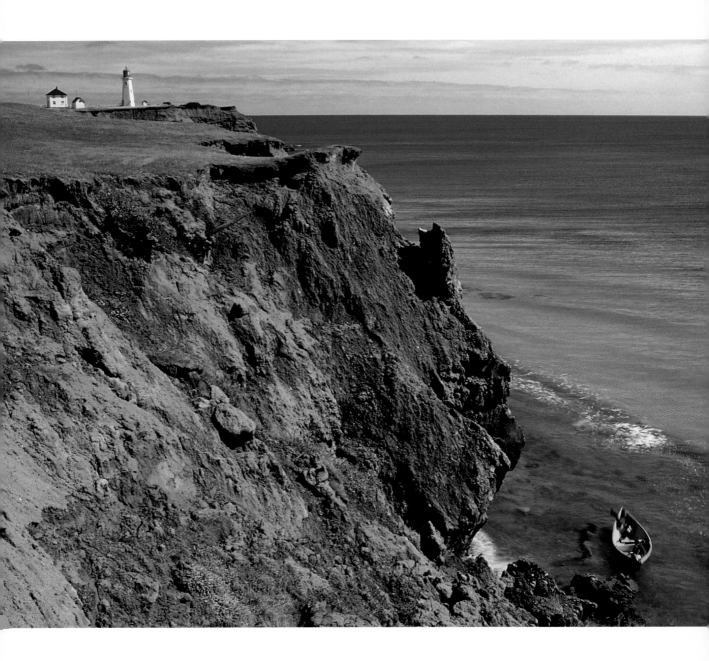

Sentinels in the Stream

Étang-du-Nord

I t's easy to find the lighthouse of Étang-du-Nord. Follow the main road, Chemin des Caps, until you reach Chemin des Phares (Lighthouse Lane). The first lighthouse was built on a bluff called Pointe Hérissée in 1874. It was the only one in the Magdalen Islands in which the lightkeeper's house and the lighthouse were one functioning unit. The first lightkeeper, Neciphore Arsenault, did not have to go far to maintain the light. In driving rain and high winds Neciphore simply had to climb a short set of stairs within his house to reach the rotating light. Other lightkeepers included Philip Turnbull and his family (1921–1947), Alfred Arsenau, Fred Turnbull, and finally, in 1947, Norman MacKay, the last lighthouse keeper in Étang-du-Nord.

Six miles (10 km) southwest from the tip of Pointe Hérissée, an immense grey rock rises from sea. Perpetually fog enshrouded and devoid of vegetation, Le Corps Mort (Dead Man's Island) owes its name to its shape, which resembles a human corpse with its arms folded upon its chest. The *Berwindlea* (1935), the *Beater* (1957) and the *Laura* (1868) are just a few of the many vessels that have gone down here. Today hundreds of seals enjoy the remoteness of Le Corps Mort, using the sunken ships as playgrounds.

On December 20, 1963, Étang-du-Nord lighthouse was witness to the sinking of the *Corfu Island*, a Greek ship belonging to Aristotle Onassis's fleet, during a violent storm with wind gusts of over 100 mph (160 kph). A copy of the last telegraph sent by the ship's captain before she sank can be seen, along with other artifacts from the wreck, at the Musee de la Mer.

The old wooden lighthouse had deteriorated beyond repair by 1967 and was sold for scrap and demolished. An iron tower was built in its place. In 1987 this tower was replaced by a taller circular iron structure that could send a beacon of mercury-vapor light 15 miles (24 km) to sea. This dioptric system was visible for a half second and eclipsed for 4.5 seconds.

On December 22, 1988, two massive dry docks that were being towed to Sydney, Nova Scotia, from Montréal broke loose in a storm and washed ashore at Étang-du-Nord. They are still visible today, a reminder to all of the power and unpredictability of the sea. Recently, a boardwalk, picnic table and benches have been built around the lighthouse, where visitors can enjoy magnificent views of the red sandstone cliffs and the breathtaking sunsets over the Gulf. GF

Sentinels in the Stream

Cap-Alright

This little red-and-white lighthouse stands forever on guard on the tiny spit of land known as Cap-Alright, which juts out into the sea and is first to greet the *M.V. Madeleine*, the gleaming white ferry that plies the Gulf of St. Lawrence from Prince Edward Island to arrive each evening in the Magdalen Islands.

Located on the island of Havre-aux-Maisons, the lighthouse is easily reached by foot along a short pathway from the main road, Chemin des Echoueries. Don't be surprised to see a busload of sightseeing tourists at this very accessible site. It happens to be one of the most widely recognized and popular tourist destinations on the Magdalen Islands. The Cap-Alright lighthouse adorns the covers of books, magazines and postcards.

To the north, this 28-foot (8.5 m) lighthouse casts a 15-mile (24 km) light towards the ominous Pelée Cliffs. To the south, the white flashing mercury-vapor light shines upon the highest cliffs of Île-d'Entrée.

Built in 1928, this square wooden tower with the red iron lantern has witnessed its share of sea tragedies. More than ten ships have run aground on either side of the cape, including the *Aberdeen* in 1857. Eroding at about an inch (2.5 cm) a year, the promontory upon which the lighthouse stands consists of brittle sandstone, its reddish hue due to the iron oxide in the soil. Clear, starry nights give this lighthouse a magical appearance, its silhouette shimmering on the sea in a silvery band of moonlight. GF

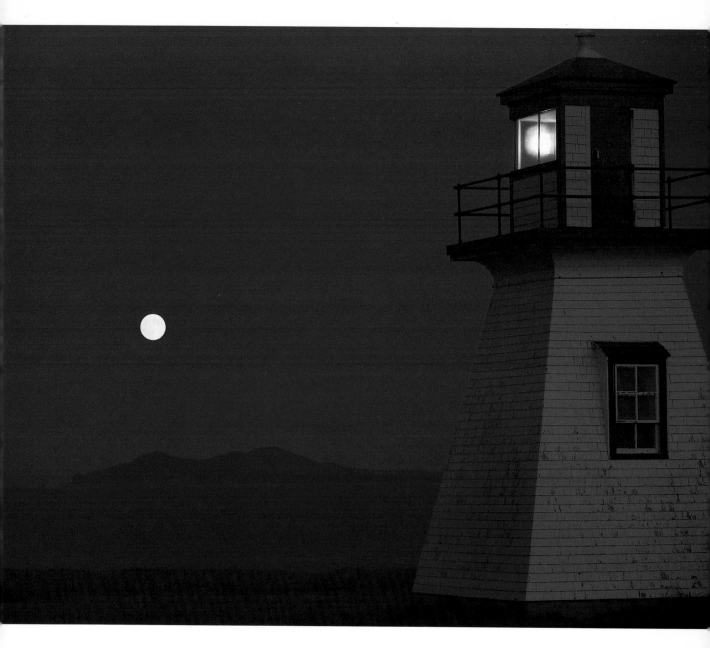

Sentinels in the Stream

Île-Brion

I le-Brion lies just 10 miles (16 km) north of Grosse-Île, one of the main group of islands that comprise the Îles-de-la-Madeleine. First discovered by Jacques Cartier in 1534 and named after French Admiral Chabot de Brion, the island is approximately 5 miles long (8 km) and 1.25 miles wide (2 km) and boasts cliffs over 200 feet (60 m).

It's about an hour trip from the harbor at Grosse-Île to Île-Brion. If you enjoy rollercoasters, you'll love the ride to Île-Brion aboard Gaston Arseneau's Zodiac. Arseneau operates sightseeing excursions to Île-Brion. Waves as high as a house crashed against the boat, sending me bouncing against its rubber edges as though I were on a trampoline.

The dock at Île-Brion is now a rusty skeleton of mangled steel and support beams. The approach to the lighthouse is along a narrow path through a forest filled with the pungent, intoxicating smell of spruce. The lighthouse itself is surrounded by a field of cranberries and waist-high grass.

Over 55 ships that have met their watery graves off the island's treacherous rocks, shoals and sandbars, with the most recent occurring in 1901 with the sinking of the ironically named S.S. *Hope.*

The octagonal lighthouse is situated on Cap-Noddy, on the western half of the island, and dominates a clearing in the surrounding forest of stunted spruce. Built in 1905, the white tower stands 37 feet (11.3 m) and has a dioptric electric white light that flashes every five seconds with an eclipse of 15 seconds after each group of four flashes. The light throws a beam that can be seen for 8 miles (13 km).

The first lightkeeper, Procule Chevrier (1905–1907), operated the light by a system of weights that made the light turn. Bobby and Felix Clark were the last to occupy the nearby Dingwell house on Île-Brion, in 1972.

In 1987 the Québec government purchased the island and turned it into an ecological reserve to protect the forest, vegetation and the more than 140 species of birds that nest there. GF

Sentinels in the Stream

92

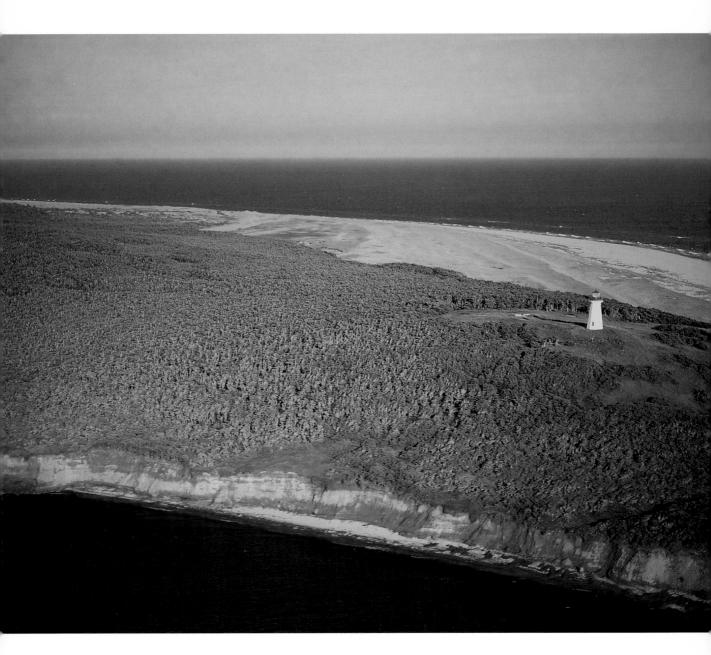

Rocher-aux-Oiseaux

This microscopic speck of rock known as the Graveyard of the Gulf appears to float on the edge of oblivion in the great Gulf of St. Lawrence, about 12 miles (20 km) off the northeast coast of Île-Brion. The *Dominion* (1903) and the *Lochmaden Castle* (1855) are just two of the more than 36 shipwrecks that encircle this perilous rock. Visited in 1534 by Jacques Cartier and in 1939 by F. D. Roosevelt, Rocher-aux-Oiseaux (Bird Rock Island) is accessible only by boat and airplane. It's often a rough and bumpy five-hour crossing from Cap-aux-Meules. Gaston Arseneau, captain of the *Pelican II*, operates a daily charter boat service to view "The Rock" when weather permits. But you can't actually dock on the island, nor can you get to the grassy plateau to view the lighthouse. The sheer 200-foot (60 m) cliffs prevent easy access, and the 152-step suspended staircase has fallen into disrepair over the years.

The lighthouse on Rocher-aux-Oiseaux was built in 1870. From 1871 to 1988 the lighthouse was manned by various lightkeepers, beginning with George Preston (1872–1874) and ending with Donat Devost (1982–1988). Until 1960, lightkeepers lived here with their families, but between 1960 and 1988 a crew rotated each month.

During the long, cold winter months, many lightkeepers relieved their boredom by venturing out onto the ice floes. In March the seals found on these ice floes were easy pickings. Keepers Patrick Whalen and John Pigeon went hunting on the ice one day only to be blown out to sea. Stranded in below freezing temperatures, Whalen froze to death, but lady luck shone on Pigeon, who survived by battling his way through ice and slush to the shore. In 1910 lightkeepers Télesphore Turbid and Damien Deveaux froze to death while hunting seals on the ice floes.

A cannon was installed in 1870. During heavy fog the cannon was to be fired at regular intervals to warn approaching ships of the rocks nearby. Fog, as it turned out, was not very good for the health of lightkeepers. On August 23, 1881, lightkeepers Paul Chenell, John Pigeon and Jean Turbid were being given a demonstration of the cannon when it backfired, igniting a keg of gunpowder. The explosion killed Chenell and Pigeon. Jean Turbid was blown off "The Rock" into the sea, but survived and swam ashore. In 1891 Télesphore Turbid lost his hand when the cannon misfired. In 1907 the deadly cannon was replaced by a compressed-air whistle. The cannon now rests at the Musée de la Mer in La Grave.

Today, Rocher-aux-Oiseaux is considered one of the most important birdwatching sites in North America. Thousands of nesting seabirds swarm in the skies. Murres, razorbills, puffins and gannets make the rocky pinnacle their home.

The best way to get a good look at the 31-foot-high (9.4 m) Rocher-aux-Oiseaux lighthouse is by airplane. Craig Quinn operates a one-hour flight from the airport at Havre-aux-Maisons. In 1962 a dynamo was installed to provide electricity to power the 400-watt mercury-vapor dioptric bulb, which when magnified by a parabolic reflector sends out a flashing beam of white light visible for 20 miles (32 km). GF

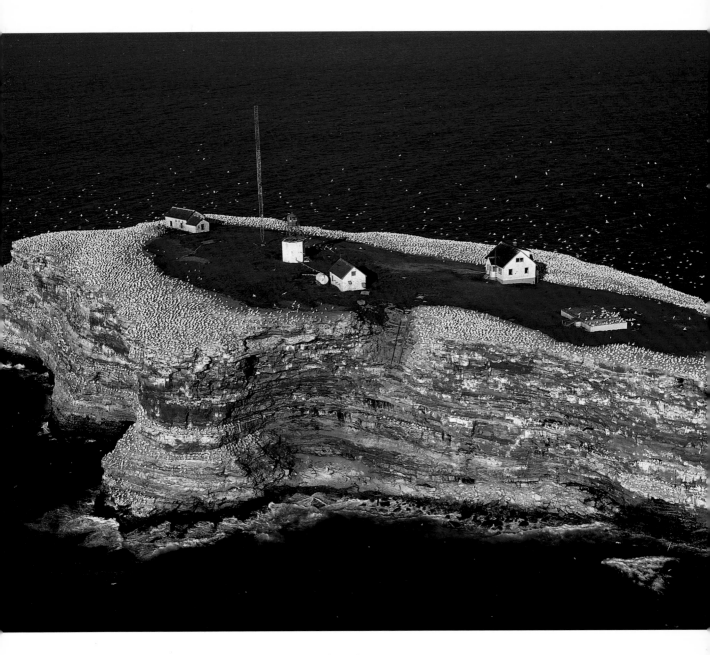

Acknowledgments

To Terry Clark, Mary Miskell, Kevin and Lisa Miskell at the Nine Mile Point Lighthouse: Thanks for the books and the beer. They were greatly appreciated after the four hours on the beach. To Arthur Frank in Alexandria Bay: Thanks for taking me to the right places at the right time with the right form of transportation — the plane and the antique wooden boat. To Bill Berthelet in Ottawa: Thanks for making all the contacts for me at the Canadian Coast Guard so that I would get the preface and the helicopter in time. To Ted Cater of Prescott Coast Guard: Thanks for the excellent preface and tour of the base, and for explaining the difference between a Fresnel light and a flashlight. To Frédéric Landry and the Musée de la Mer in the Magdalen Islands: Thanks for all the information on lighthouses of the Magdalens. To Michel Fiset of Prescott Coast Guard Base: Thanks for the unbelievable helicopter maneuvering that you did so that I could get the best shots possible of the lighthouses in the St. Lawrence. GF

I would like to thank my friend George Fischer for his energy and for finding a publisher for this book; my wife, Linda, who typed my texts and supported me; and José Demers Beaudet, my translator, always available; Donald Moffet, Claudine Perron and Marie-Ève of the Coast Guard, for giving me access to their files; Yves Foucrault of the La Martre lighthouse, for the same reasons and for his passion; René Trépanier of Québec Maritime, who made my trips easier in many ways; Renée Martineau from Sépaq, my guide at Anticosti; biologist Pascal Samson and the people of Safari Anticosti, for their welcome; Réjean Frénette of the Pointe-des-Monts lighthouse, for the seal; Jean-Hugues Roy, responsible for air transport for the Canadian Coast Guard, and Daniel Dubé, the helicopter pilot; Gaétan Bouchard, for his taxi-boat in Sept-Îles; Jean Bédard and the whole team at Duvetnor, for my stay at Île-du-Pot-à-l'Eau-de-Vie; Raymond Lalonde of Cap-d'Espoir; and my friends Gilles Côté of Barachois, Léontine Verge of Carleton, Christiane Labelle and Gérald of Saint-Alexis, Jean-Yves Lévesque of Ste-Anne-des-Monts, Réjean Côté, and Johanne and Lionel Gionet of Baie Ste-Catherine, who opened their doors to me so often. CB

We would both like to express our gratitude to the men and women of the Canadian Coast Guard for the invaluable service they provide Canadians and for the immeasurable assistance they have provided us in the preparation of this book.

Bibliography

Canadian Coast Guard. *Atlantic Coast List of Lights, Buoys and Fog Signals*, 1990.

Collections of the Museum de Pointe-au-Père.

Landry, Frederic. *Captains of the Shoals*. Editions La Boussole, 1994.

Landry, Frederic. *Derniere Course*. Editions La Boussole, 1994.

Landry, Frederic. *Pieges de Sable*. Editions La Boussole, 1994.

Penrose, L.A. *Travel Guide to 100 Eastern Great Lakes Lighthouses*. Freide Publishing, 1994.

Public Broadcasting System. *Lighthouses of the Seaway Trail*, 2000.

Wright, Larry and Patricia. *Bright Lights, Dark Nights: Great Lakes Lighthouses*. Boston Mills Press, 1999.

Ile-Verte website: www.ileverte.net

U.S. Coast Guard website: www.uscg.mil

Canadian Coast Guard website: www.ccgrser.org